Watercolor
Workshop II

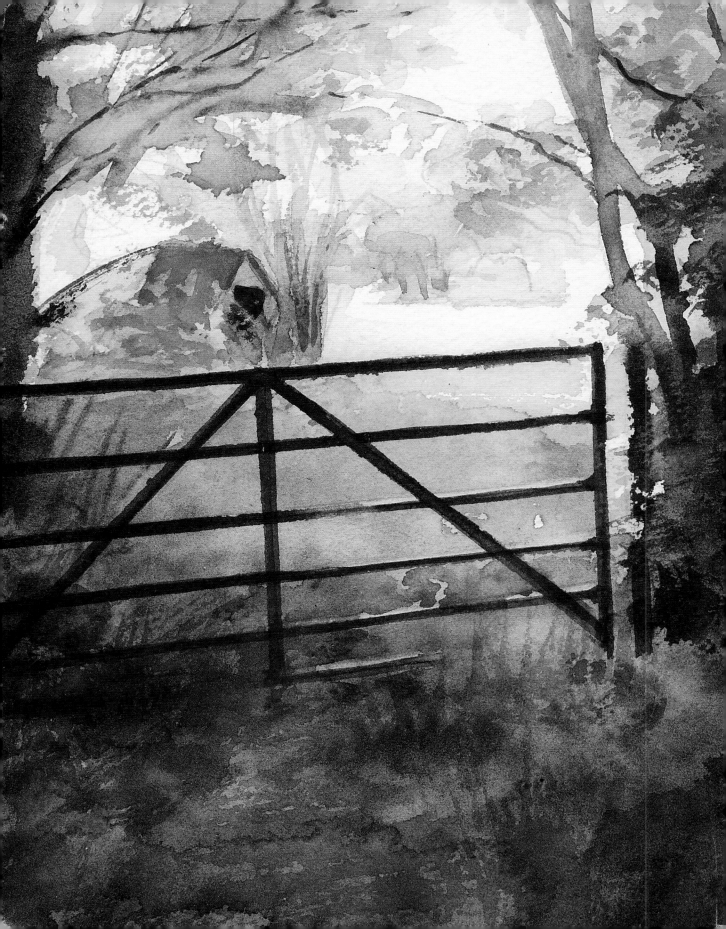

Watercolor
Workshop II

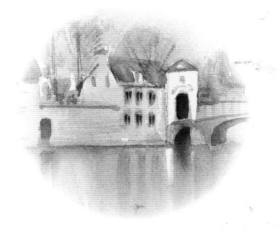

Glynis Barnes-Mellish

LONDON, NEW YORK, MELBOURNE,
MUNICH, DELHI

Senior Editor Angela Wilkes
Senior Art Editor Mandy Earey
Production Editor Sharon McGoldrick

Managing Editor Julie Oughton
Managing Art Editor Christine Keilty
Production Controller Louise Minihane
US Editor Meg Leder

Photography Andy Crawford

**Produced for Dorling Kindersley by
Sands Publishing Solutions**
Project Editors Sylvia & David Tombesi-Walton
Project Art Editor Simon Murrell

First American Edition, 2007

Published in the United States by
DK Publishing
375 Hudson Street
New York, New York 10014

07 08 09 10 11 10 9 8 7 6 5 4 3 2 1

PD187–May 2007

Published in Great Britain by Dorling Kindersley Limited.

A catalog record for this book
is available from the Library of Congress.

ISBN: 978-0-7566-2857-4

DK books are available at special discounts when
purchased in bulk for sales promotions, premiums,
fund-raising, or educational use. For details, contact:
DK Publishing Special Markets, 375 Hudson Street,
New York, New York 10014 or SpecialSales@dk.com.

Color reproduction by Wyndeham Prepress, London
Printed and bound in China by
Hung Hing Offset Printing Company Ltd

Discover more at
www.dk.com

Contents

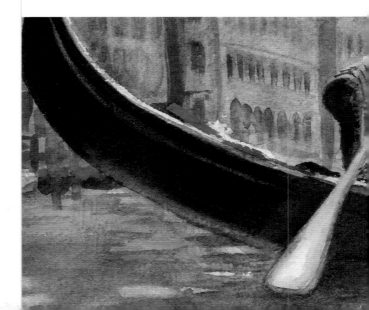

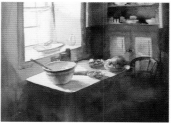

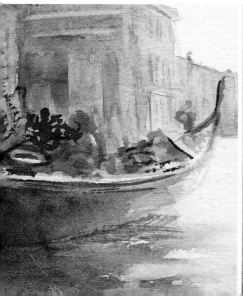
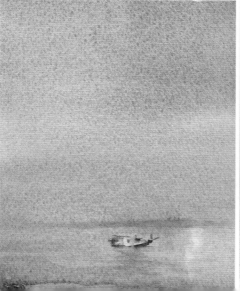
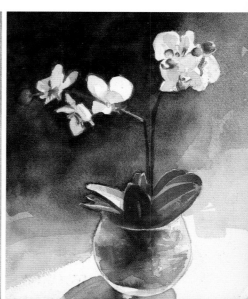

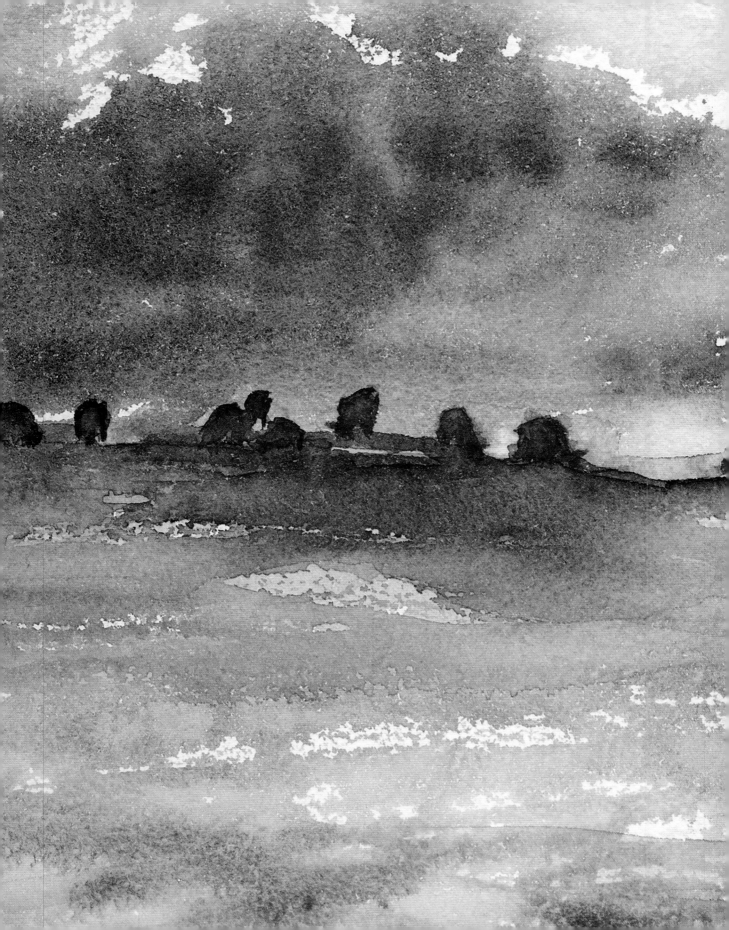

Introduction

Painting in watercolor is one of the most exhilarating and rewarding areas of picture-making. The translucent qualities of the pigments give your work a luminous glow, and watercolor is very flexible, equally suited to loose, fluid sketches of landscapes and technically accurate botanical studies. It really comes into its own, however, when you work with total artistic freedom. You can blend the colors in a way that simply isn't possible with other types of paint, due to the leisurely pace at which watercolors dry on paper. You can continue mixing colors after you have applied them, composing with the paint in a spontaneous way, or leave each layer of paint to dry before adding more color. If you are prepared to experiment a little and take advantage of this fluidity, you can produce vibrant and expressive paintings.

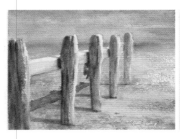 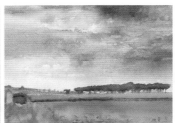 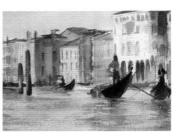

Improving your skills

In this book you will learn how to build upon the skills that you have already acquired. By now you probably have a good grounding in basic techniques, such as how to apply washes and build up layers of color. You will also know about tone, perspective, and creating focal points. Now you can take this knowledge further, learning how to apply basic principles to new situations, adapt techniques to suit your needs, and create more complex pictures. This can only be achieved with some careful planning from the outset, and this is where this book starts.

There are several ways to plan your paintings, and here you can find out how sketches and photographs – or a combination of the two – can provide a starting point for your work. You can also find out what to consider when composing your paintings. If you plan your work carefully and have a good idea of what your picture should look like from the start, there is less chance of making mistakes while painting. Although you can correct mistakes in watercolor, significant alterations reduce your chances of producing a fresh, luminous piece of work. This would be a shame, since the vibrancy of watercolor is what makes it so appealing.

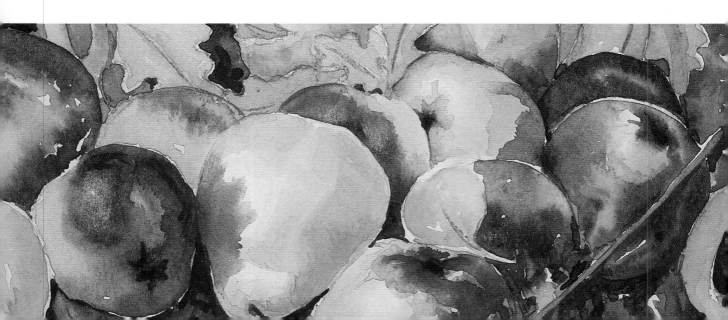

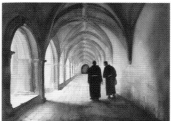
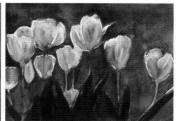
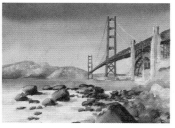

Successful painting

The aim of this book is to help you improve your watercolor skills so that you can create successful pictures regardless of what you are painting or how much time you have. While the guidelines and principles are common to all forms of painting, they are particularly pertinent to watercolors. Because watercolors are translucent, you need to learn how to build up a painting from the lightest to the darkest tones with minimal corrections. As you grow in confidence and work faster, you will have greater scope to express yourself freely and experiment with the paint.

The projects in this book are grouped into landscapes, still life, people and animals, and interiors, and the learning points in each section demonstrate how best to approach the unique aspects of each subject. Of course, there is always more than one way to interpret something, so it helps to understand the subject you have chosen. To inspire you, each chapter includes a gallery of paintings by old masters and contemporary artists, showing how they have interpreted a particular theme. Your fascination with your subject will be reflected in your work and will help you to produce fresh and innovative paintings.

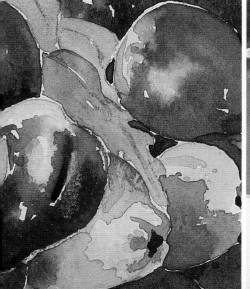
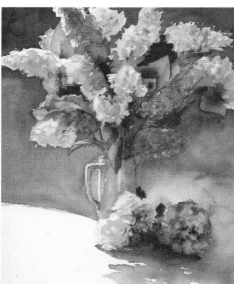
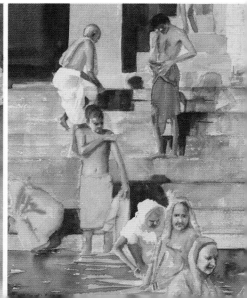

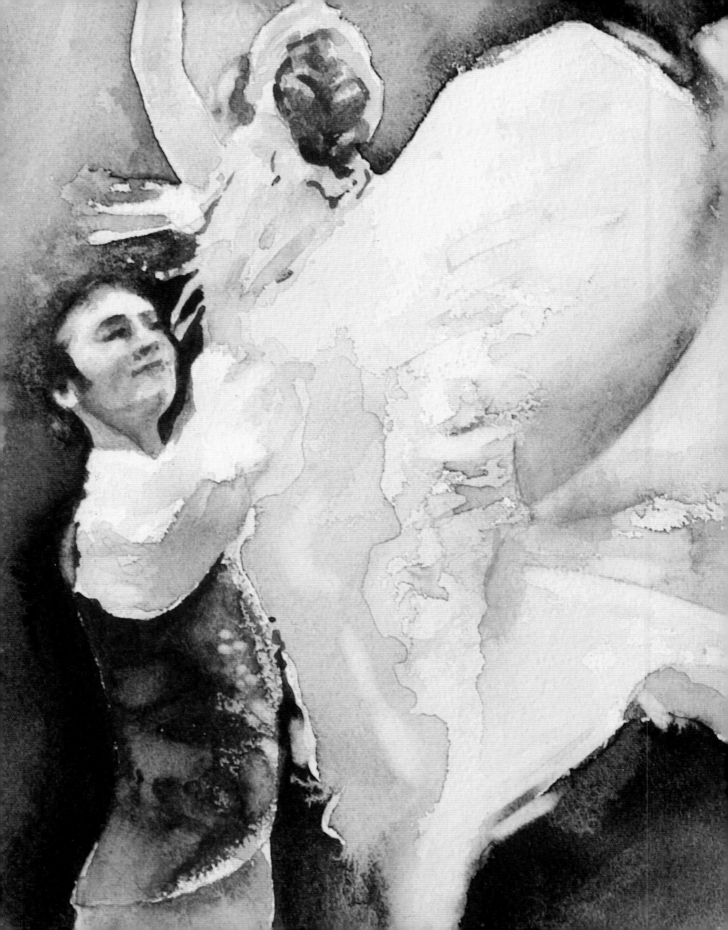

Starting Points

Materials

The most important materials for a watercolorist are paints, brushes, and paper. Paint can be bought either in tubes of fluid pigment or in solid blocks called pans. You can create a vast range of effects with just a small number of brushes, but it is wise to buy the best you can afford. Choice of paper is a far more fluid affair, since you may well use different types, depending on the subject you are tackling.

PAINT

As you become more experienced with your watercolor work, it is normal to want to expand your palette of colors. You should always buy the best-quality paints you can afford. However, cheaper paints may allow you more creative freedom and permit you to experiment more readily. Worrying about wasting your art materials is a disadvantage when you are trying to paint without restraint. An important consideration, though, is that the more costly artists' colors offer greater control and stability in mixing. These paints are also more transparent than students' colors, making for more luminous pictures.

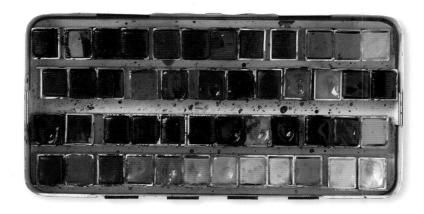

CHARTING COLORS

Often when you buy a palette of artist-quality paints, it will come with a sheet illustrating how the paints look on paper. In most cases, this will be a printed slip, and it is worth bearing in mind that the colors on it may not be as accurate a representation as you would like. It is therefore a good idea to make your own color chart. Take a piece of watercolor paper – ideally the type you use most often – and paint a small gradated swatch of each color in the palette, remembering to label each one as you go. This will serve as an invaluable reference in your work.

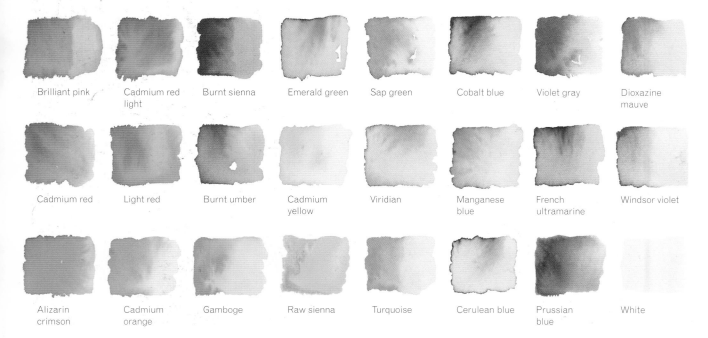

Brilliant pink	Cadmium red light	Burnt sienna	Emerald green	Sap green	Cobalt blue	Violet gray	Dioxazine mauve
Cadmium red	Light red	Burnt umber	Cadmium yellow	Viridian	Manganese blue	French ultramarine	Windsor violet
Alizarin crimson	Cadmium orange	Gamboge	Raw sienna	Turquoise	Cerulean blue	Prussian blue	White

BRUSHES

Whatever type of brushes you buy, it is vital that they have a good point and hold their shape. They should also hold plenty of paint. Your choice of brush types includes sable, synthetic, and sable/synthetic blends. The most expensive type – and the best – is the sable, but the other two types have been created with the intention of replicating the traditional brush.

½ in (12.5 mm) flat

Larger flat brushes are best used for applying washes.

1 in (25 mm) flat

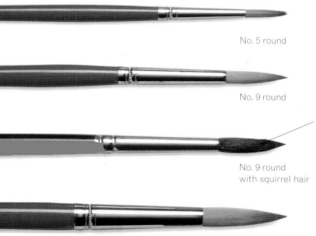

No. 5 round

No. 9 round

This softer round brush is ideal for blending.

No. 9 round with squirrel hair

No. 14 round

2 in (50 mm) hake

PAPER SURFACE

Your choice of paper surface will be influenced by the type of painting you wish to do. A very smooth, hot-pressed paper allows for a great deal of fine linear detail and precision. A cold-pressed, or Not, paper is the most versatile – it tolerates a good level of intricate detail and offers great fluidity. A paper with a rough surface is the most accommodating for producing textures and free-flowing inspirational pictures.

The smoothness of this aubergine is created through the use of a hot-pressed paper.

The pitted surface of this rough paper has broken up the painted wash.

Making choices

For watercolor work, it is very important to plan in full detail what you are going to do in the painting. Although allowing a picture to develop as you go is very liberating, an unplanned work is likely to be unstructured and muddled. Most loosely painted watercolors that look improvised have actually been meticulously planned. The amount of planning you choose to do may depend on your experience and confidence, but there are some choices that can help you know what to expect from your work.

CHOOSING A SUBJECT

Finding a subject to paint is always successful if you start with things you like or to which you are sympathetic, or that contain elements – such as color or topic – that excite you. Having strong feelings about a subject will immediately lead you toward knowing how to portray it.

Watercolor is so flexible that it is a suitable medium for any subject matter – from the energy of people in action, to the calm of a still life. Once you have chosen your subject and before starting to paint, you will often need to create reference material, since it may not be possible to keep the actual subject exactly as you want to portray it.

SKETCHBOOKS

One helpful way to plan your painting is to make detailed sketches of your subject beforehand. These days, many painters turn to photography to capture their source material, but there is no reason why you cannot use the methods tried and tested by the old masters. Indeed, one of the key benefits of working in this way is that it helps you get a feel for the subject you are sketching, which is vital when it comes to putting your brush to paper later, especially so in watercolor.

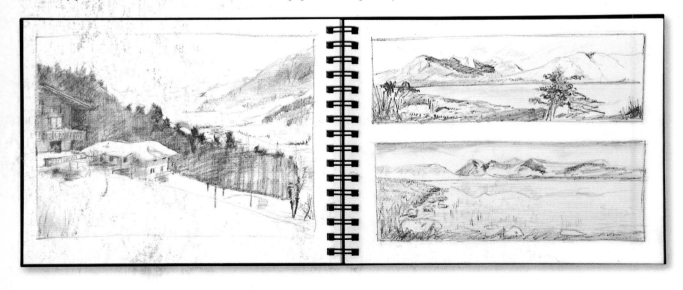

WORKING FROM PHOTOGRAPHS

The key to making successful paintings from photographic reference is to take as many photographs as possible. It is the easiest way to get reference for a subject for painting and is essential if it's a subject you won't see again. Use the viewfinder of the camera to observe the subject in many different ways and from more than one angle, where possible. The photos add together to reconstruct the scene in your mind. This way, you will stimulate your memory and create a more evocative painting than trying to recreate the scene from just one photograph.

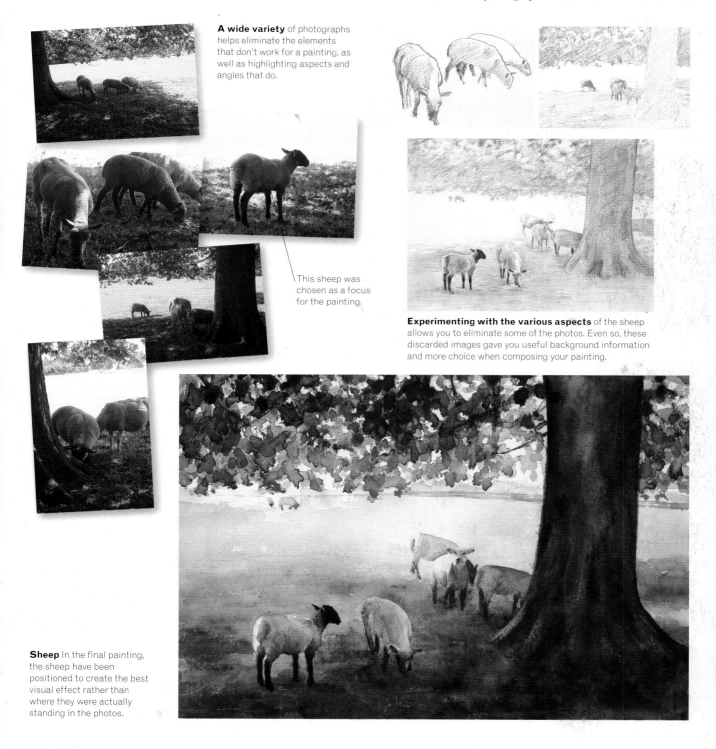

A wide variety of photographs helps eliminate the elements that don't work for a painting, as well as highlighting aspects and angles that do.

This sheep was chosen as a focus for the painting.

Experimenting with the various aspects of the sheep allows you to eliminate some of the photos. Even so, these discarded images gave you useful background information and more choice when composing your painting.

Sheep In the final painting, the sheep have been positioned to create the best visual effect rather than where they were actually standing in the photos.

Color

It is essential to become familiar with the qualities and characteristics of your paints. By making a record of the combinations from your palette and how the colors work with each other, you will speed up your mixing and avoid buying paints you don't need. By initially restricting the number of colors you use, you will find it easier to memorize their properties. Most pictures work best with only a limited palette.

COLOR RELATIONSHIPS

The primary colors are the three colors that cannot be made or created from any others. They are red, yellow, and blue. Mixing any two primary colors creates a secondary color, of which there are three: green, violet, and orange. Each primary color also has a complementary "secondary" color; this is the color created by mixing the other two primary colors. For example, the complementary color for red is green (yellow + blue). Tertiary colors are formed when mixing a primary color with a secondary color. Examples include yellow-green, red-orange, and blue-violet.

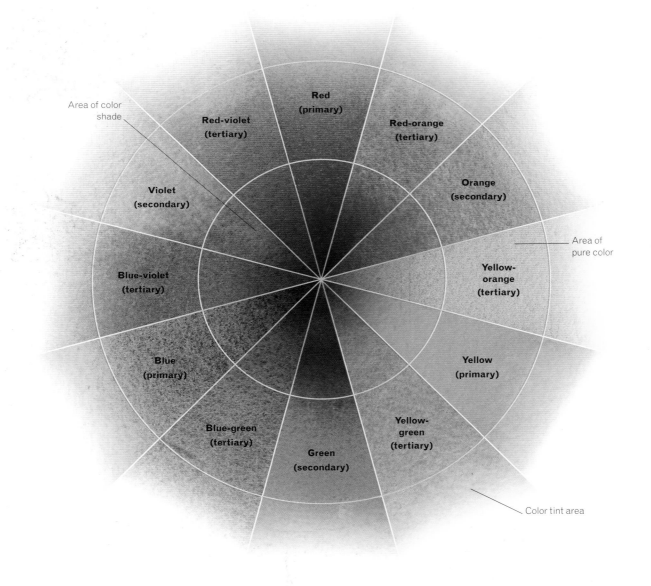

Area of color shade

Red (primary)

Red-violet (tertiary)

Red-orange (tertiary)

Violet (secondary)

Orange (secondary)

Area of pure color

Blue-violet (tertiary)

Yellow-orange (tertiary)

Blue (primary)

Yellow (primary)

Blue-green (tertiary)

Yellow-green (tertiary)

Green (secondary)

Color tint area

COLORS THAT WORK TOGETHER

The chart below shows color relationships and pigments in action. Get to know the paints you use, and find out how they interact with one another: how they behave when mixed together in the palette, blended on the paper, or layered is vital to successful watercolor painting. Not all reds and blues make a vibrant violet, and not all yellows and reds combine to make a pure orange.

BUILDING UP COLOR

When French ultramarine is layered over cobalt blue, the colors remain separate.	A varied wash of cadmium yellow merged into emerald green makes an opaque yellow-green.	The transparent alizarin crimson pigment spreads easily when added to cadmium yellow.

COMPLEMENTARY COLORS

Cadmium yellow and Windsor violet are pure complementaries, making each more vibrant.	Viridian perfectly enhances slightly neutral mauves, while a pure green would be too overpowering.	Pure blue and orange combine to create a harmonious and vibrant color scheme.

RESTRICTING COLOR

Mixing color on the paper produces a variety of luminous and varied grays.	Combine just a small amount of pure color with limited complementary colors to add excitement.	Create glowing shadows by mixing transparent pigments such as raw sienna and Windsor violet.

COLOR FOR PERSPECTIVE

The use of gradation to produce depth and unity is highly suited to watercolor because water-soluble paint lends itself to blending so easily. Gradation of size and direction produces linear perspective. Gradation of color (from warm to cool) and tone (from dark to light) produces aerial perspective.

Pale, cool colors create a sense of distance.

The middle ground is made up of a mix of cool and warm colors.

Warm colors, such as reds and browns, bring an area forward in the composition.

Aerial perspective The gradation of color, from warm to cool, has produced depth and aerial perspective in the scene.

Tone

Despite being the primary feature in any painting, tone is also the least understood element. Tone controls the whole surface area of a picture, while at the same time highlighting areas of focus. Too much variation in tone, however, can destroy a picture's unity. Consider carefully where to place the areas of maximum contrast. The lightest and darkest tones should be located at the heart of interest and focus.

LIGHT AND DARK

Tone is a relative concept, based on the interaction between different shades. As such, the greatest variety of tone is seen in paintings that use only a limited number of colors. Without intelligent use of tone, a painting will lack focus and depth. Furthermore, if a picture is made up of colors of a similar tone, the end result will be a dull image.

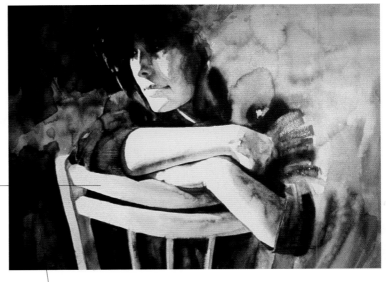

The lightest tones are in the face, arms, and chair back.

Davina In this painting, the strong tonal contrast from the very bright light source creates an image that is striking and powerful. The subtlety in the midtones supports this strong focus.

Background tones are close in contrast.

Dark tones are blocked together to frame the picture.

Tonally close bright colors unify to create movement.

CONTRAST AND ALTERNATION

By placing dark and light tones together throughout a picture, the whole work will have clarity. How light or dark these tones are will vary according to where they are placed in the painting and the amount of contrast and tonal difference needed. The area of greatest tonal contrast is the point of focus, so the difference between tones should be less marked elsewhere.

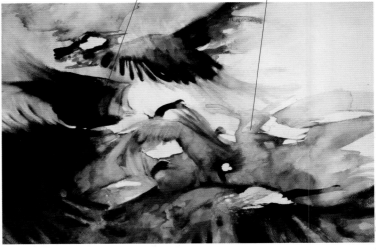

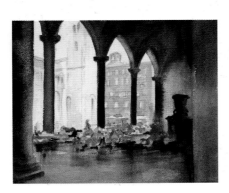

Flower market, Lucca Visual excitement has been created in this picture through the contrast between bright colors and muted cool colors.

Geese Key to the design of this painting are the swathes of light and dark that divide it into areas of interest. The alternation in the work – from the very dark wing shapes at the edges of the picture, to the lighter, similarly toned colors at the center – has produced drama and tension.

FOCAL POINT

A strong focal point is an essential element of any good painting, and it should immediately draw the eye to the main area of interest. In any image, the point where the lightest and darkest tones meet is the focal point. The lightest and darkest tones may be used elsewhere, but they should be placed next to each other only where you want to focus attention. Here, the focal points are the the male dancer's face and his partner's hair. Notice how the tones used around those areas are restricted; this is done so as not to detract attention from the focal point.

Movement of the figures is suggested by the swirl of neutral colors.

The lightest and darkest tones meet at the man's face and woman's hair, focusing attention there.

Darks in the background suggest form without vying for attention.

Ballet dancers
A definite area of focus has been created in this painting at the only point where the lightest and darkest tones meet at full contrast. This produces a relationship between the dancers. All the other marks are less sharp, suggesting movement, and the close tones create a strong design over the whole picture.

Composition

Once you have decided on a subject, you must plan the composition. Having made studies or thought about the emotions urging you to make a painting, it is then necessary to determine a layout. This is your chance to fully consider, and reconsider, your approach to the painting. This will make things clearer for you and help you decide what design will show the subject matter or scene to its best advantage.

STUDIES

Doing sketches and small color studies allows you to see how different compositions and color schemes work. This is a wonderful way to concentrate your thoughts and make decisions about how the painting will eventually look. For this reason, your studies should be executed quickly and freely, to open up a variety of emotional responses. These studies can then be used as the foundation for your painting, along with more detailed reference.

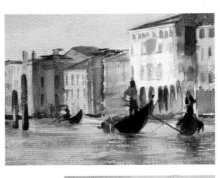

Pencil studies can be quick observations that capture movement and change. There is no need to worry about being too precise or accurate with such sketches.

Color studies are a way to make simple notes on changes in light or atmospheric conditions while experimenting with colors.

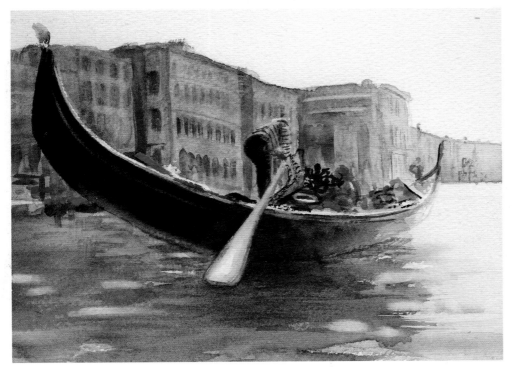

Gondola scene Both of the studies above have their merits and could be worked up into a full painting.

Grand Canal The final composition is a close-up of the gondola. This makes it possible to show some of the boat's intricate details and makes the gondolier an integral part of the painting. This powerful image utilizes the majestic beauty of the gondola, while the paddle halts the viewer's focus, drawing attention toward the buildings on the canal.

GRADATION

Visual interest can be added to a painting through the use of gradation. Any progression from dark to light will cause the eye to follow it, while gradation of size and direction produces linear perspective. A simple but effective way to draw the viewer's attention to a specific point in a picture is to break the gradation. This will halt the eye's movement at that point.

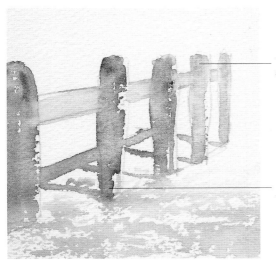

The lighter tones create a sense of distance.

Elements in the foreground are painted in darker tones.

Linear perspective Here, size and direction gradation, from dark to light, creates linear perspective, moving the posts into the distance.

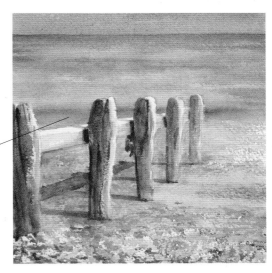

The viewer's eye is drawn to the warm colors of the horizon line.

Broken watercolor The way the posts break the gradation at the water's edge halts the eye's movement along the row, focusing attention there.

DIRECTION

The element of direction can have an incredible effect on a painting's feel, yet it is very often forgotten or ignored as we allow the subject to dictate the dominant direction. Sometimes, though, the subject will allow you to impose a direction on it. This means that you will have both control over the work and a distinct effect on the finished work's character.

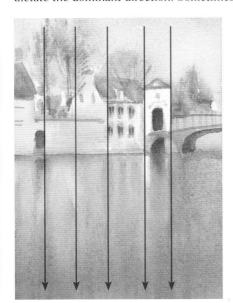

The vertical appearance of this study gives a sense of balance, formality, and observation. The vertical lines in the water counter the structured look of the buildings.

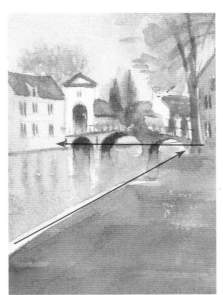

The diagonal lines in this study imply movement and action – from left to right, from the foreground to the bridge. The diagonal pathway then moves from the right bank to the buildings.

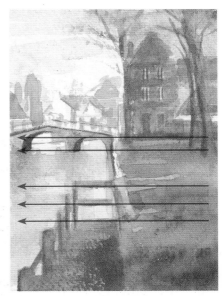

This study has moved even further round to maximize the horizontal lines of the jetty and bridge. Calmness, stability, and composure are suggested by the buildings and trees.

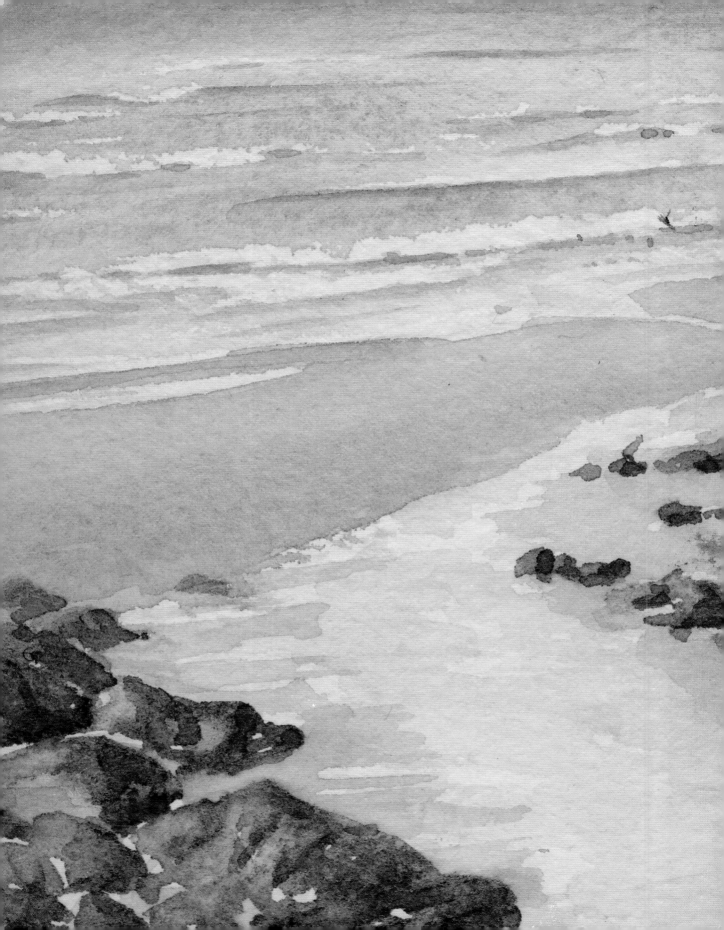

Landscapes

"A sense of scale
lies at the heart of every
successful landscape."

Landscapes

Perspective is often the first thought that comes to mind on hearing the word "landscape" in art – trees disappearing into the distance through vast rolling fields, for example. One of the chief uses of perspective is in defining scale within a picture. And through the use of scale, you can also create drama in a scene, highlighting the relationships between small and large elements.

MOOD AND DRAMA

The simplest way to create mood in a landscape is probably through the use of dominance. Select your main area of interest and bring it forward in the painting by using darker tones. In this picture, the lower third is the dominant part. The inclusion of the boat on the lake plays two key roles: not only does it add to the mood of the piece, but it also creates a sense of scale.

There is no defined area within the picture here, and all the surface is equal in tone.

With the picture now in two unequal parts, the top part is dominant, with its stronger tones.

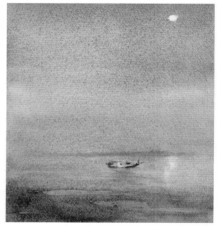

The darker foreground here and the addition of the boat have made the lower third the dominant area.

GRADED TONES

Within a painting, gradation – the use of graded tones of one color – produces both perspective and unity. This technique works particularly well with watercolor because water-soluble paint lends itself to blending. Gradation – of tone, from dark to light; and of color, from warm to cool – creates aerial perspective.
Use gradation to add interest and movement to a shape; a progression in tone from dark to light will lead your eye into a painting.

Graded tones of green create a sense of perspective in this painting. The darker tones in the foreground indicate that this area is closer to the viewer, whereas paler colors are used to convey distance. The grass that is farthest away is paler in both tone and color.

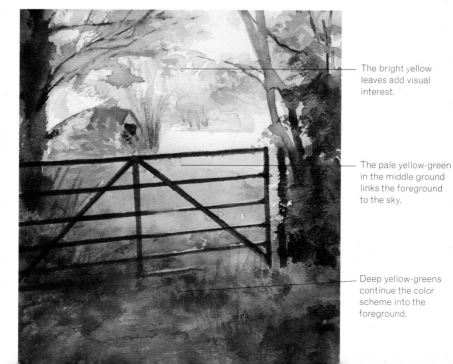

The bright yellow leaves add visual interest.

The pale yellow-green in the middle ground links the foreground to the sky.

Deep yellow-greens continue the color scheme into the foreground.

PERSPECTIVE AND SCALE

Gradation of size is used to create a sense of
perspective in this picture. By painting two objects
of similar dimensions at different sizes, you create
a sense of distance between them. Colors and
tones are also graded in this picture, to add even
greater depth to the scene.

The varying sizes of the
legs of this hut, as well
as the use of light and dark
tones next to each other,
halts the viewer's attention
at this point. It is this part
of the painting that grounds
the whole scene.

The pure blues
used in the hut
create focus.

A cool blue is used for
the sky, helping to push
it into the distance.

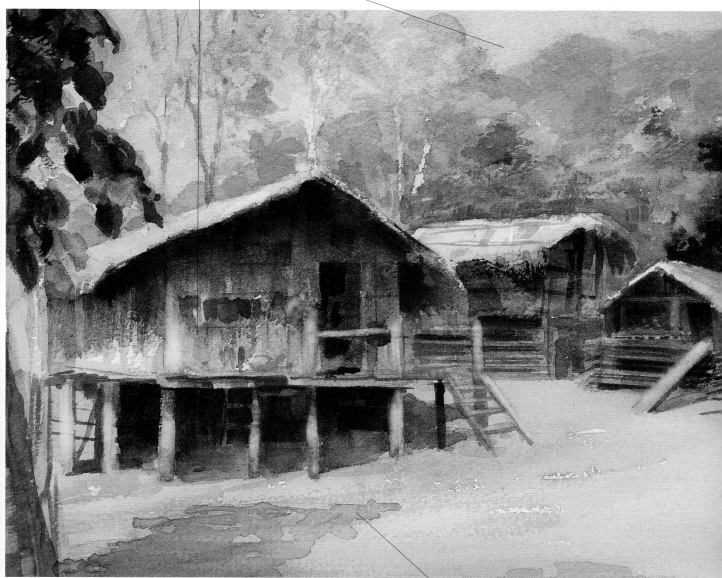

Bamboo huts This painting is completely harmonious
thanks to the use of various shades of blue that unite
all the areas. The different sizes and angles of the huts
produce a rhythm and pathway across the whole picture.

This graded lilac shadow helps
create a sense of distance between
the viewer and the first hut.

Gallery

◀ Marshland farmhouse

This painting of a dramatic sky at sunset is the perfect example of how bold watercolors can be. The colors have been worked wet-in-wet to portray the emotional and sensational landscape setting of a turbulent dusk. *Emile Nolde*

▼ Lakeside in autumn

Green and red in close relationship work well here and link all the positive and negative spaces, giving the painting both balance and unity. *Phyllis McDowell*

▲ Logging House, Italy

Bright yellow has been used beneath all the colors in this painting to create a feeling of early evening and a low, setting sun. The shadows have been kept warm and long to suggest the time of day. *Glynis Barnes-Mellish*

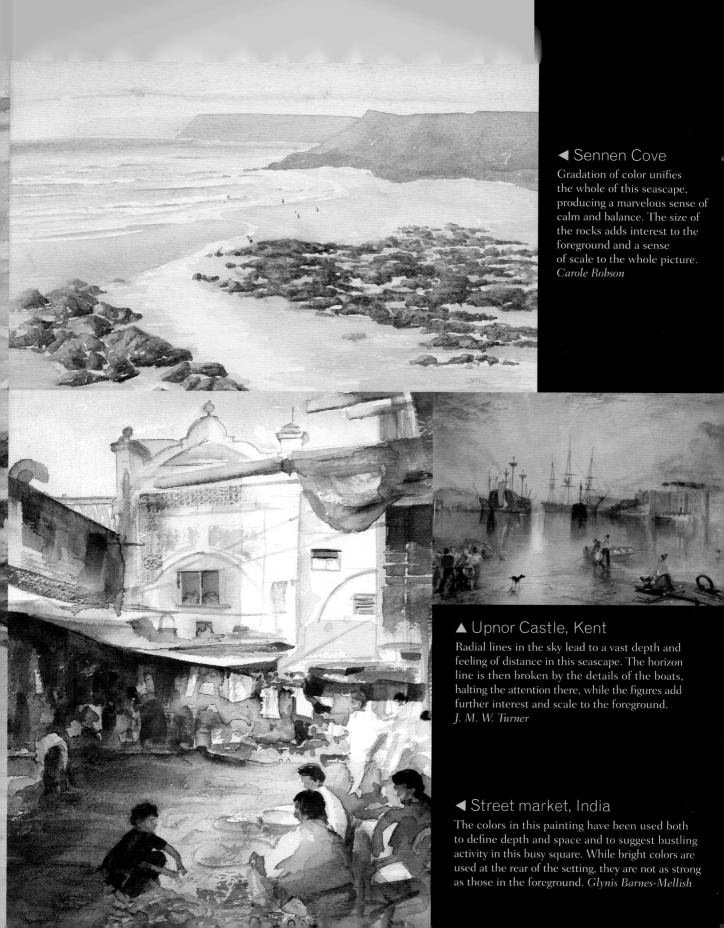

◀ Sennen Cove

Gradation of color unifies the whole of this seascape, producing a marvelous sense of calm and balance. The size of the rocks adds interest to the foreground and a sense of scale to the whole picture. *Carole Robson*

▲ Upnor Castle, Kent

Radial lines in the sky lead to a vast depth and feeling of distance in this seascape. The horizon line is then broken by the details of the boats, halting the attention there, while the figures add further interest and scale to the foreground. *J. M. W. Turner*

◀ Street market, India

The colors in this painting have been used both to define depth and space and to suggest bustling activity in this busy square. While bright colors are used at the rear of the setting, they are not as strong as those in the foreground. *Glynis Barnes-Mellish*

1 French vineyard

In this landscape, the strong chromatic dominance of the sunset sky creates drama and excitement. All the other tones are subordinate in both saturation and contrast. The addition of dark tones breaks up the vast expanse of green and gives definition to the bushes in the immediate foreground. The darker separating line across the center of the painting prevents the perspective of the vines from dominating the composition and defines a second field. Meanwhile, the dark tone of the trees on the left helps draw your eye toward the farmhouse.

EQUIPMENT
- Rough paper
- Brushes: No. 5, No. 12, 1 in (25 mm) flat, hake, squirrel
- Cadmium yellow, French ultramarine, alizarin crimson, lilac, cadmium orange, cobalt blue, Prussian blue, burnt umber, raw sienna, burnt sienna, cadmium red

TECHNIQUES
- Chromatic gradation
- Dry brushwork

The paper should have lost its wet sheen before you start painting but not be completely dry.

"The wet-in-wet wash can give soft shapes and interesting chromatic variations."

1 Turn the paper upside down to paint the sky; this will prevent drips. Brush clean water over the sky with the hake brush. Apply cadmium yellow and a purple mix of alizarin crimson and French ultramarine with horizontal strokes of the No. 12 brush.

2 Continue adding color to the sky, rotating the paper as necessary so that the colors run into one another in places. Create the undersides of the clouds by dabbing at the sky with dry tissue paper. Leave to dry.

BUILDING THE IMAGE

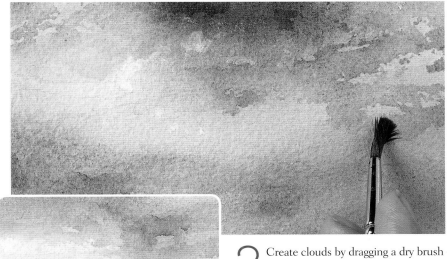

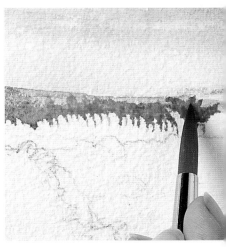

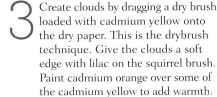

3 Create clouds by dragging a dry brush loaded with cadmium yellow onto the dry paper. This is the drybrush technique. Give the clouds a soft edge with lilac on the squirrel brush. Paint cadmium orange over some of the cadmium yellow to add warmth.

4 Paint the horizon line with pure cobalt blue to create a cooler feel. Add a little of the stronger Prussian blue to the center of the horizon to create shade beneath the trees.

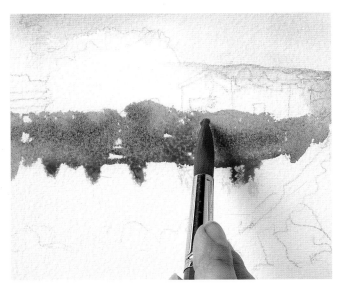

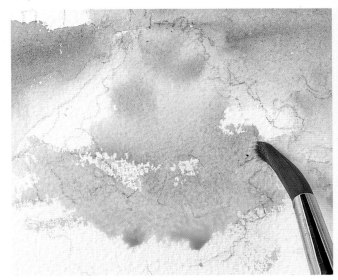

5 Use a mix of cadmium yellow and Prussian blue for the brighter greens at each side of the center part of the picture. Make a stronger mix of this blend (with more Prussian blue) for the lower, foreground elements. Use the No. 12 brush.

6 Add water to the brighter greens with the squirrel brush to dilute the colors and bring them further down the paper. This creates the impression of the vines in the foreground of the picture area.

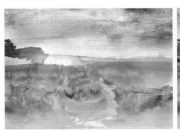

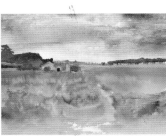

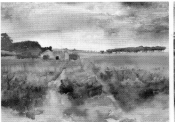

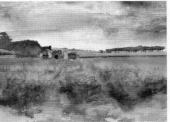

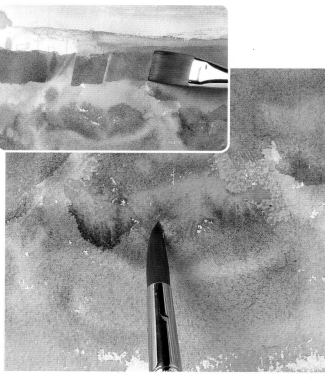

7 Use a French ultramarine and burnt umber mix for the mud tracks, and alizarin crimson and raw sienna for the gray-brown foreground earth. Use a Prussian blue and cadmium yellow mix for the foreground vines, and add burnt sienna highlights.

8 Using a flat brush, apply a mix of Prussian blue and cadmium yellow in horizontal strokes to create the vines on the left and right of the picture. Add detail to the vines using a cadmium yellow wash, pushing the pigment away.

DIRECTING THE FLOW

Don't be afraid to take the paper in hand and turn it around in various different directions if the paint is flowing where you don't want it to go.

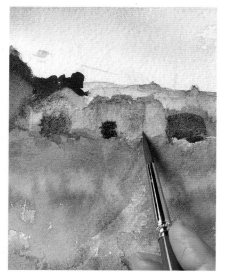

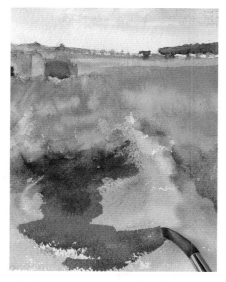

9 Create the line of trees on the horizon with a green mix of Prussian blue and cadmium yellow. Soften the trees with a mix of alizarin crimson and French ultramarine, using the No. 12 brush.

10 Paint the houses with the gray-brown mix from Step 7, and the roof on the left with cadmium red to complement all the green. Add details on the houses with burnt sienna and a little of the purple mix on the No. 5 brush.

11 Use pure Prussian blue for the trees behind the houses and in the right-hand background. Darken the foreground vines with the mix of Prussian blue and cadmium yellow. Add more cadmium yellow to the mix for the foreground.

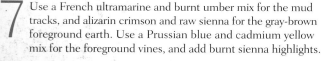

12 Mix cadmium yellow, alizarin crimson, and French ultramarine to make a caramel color for the tracks. Use the Prussian blue and cadmium yellow mix to paint a separator to split the similar tones of the two fields on the right.

13 Paint shadows in the vines with a fine brush and burnt umber. Brighten the roof with a cadmium yellow and cadmium red mix. Tone down the tracks with dabs of caramel; add horizontal track marks in burnt umber.

▼ French vineyard

The wet-in-wet technique has produced extremely strong coloring in this sunset. This is supported with muted colors in the rest of the painting to describe the low light of the fading sun.

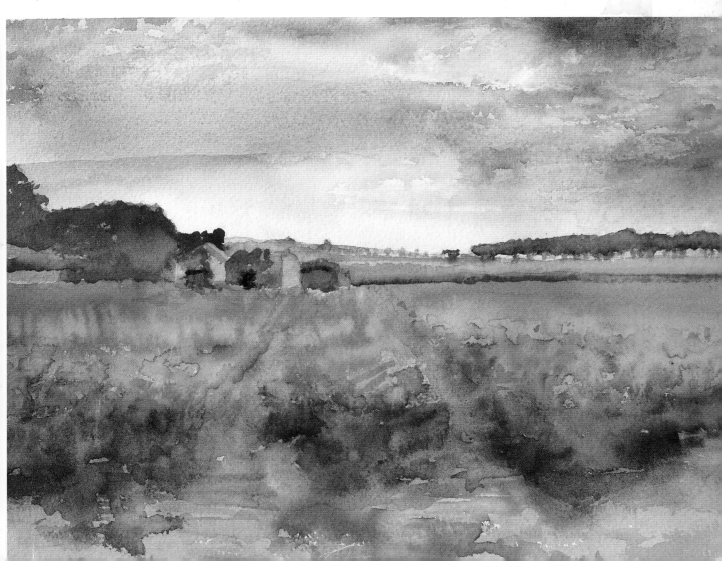

②Golden Gate Bridge

This painting owes its impact to the sheer scale of the subject. The important thing here is to make sure that the rocks in the foreground are large enough to act as a counterpoint to the bridge. If you make them too small, the bridge in the distance will look unbalanced, as if sitting in a puddle. The dominant size and uneven groupings of the rocks establish a solid structural setting for the sweeping arch of the bridge, which divides the composition and creates a strong diagonal that leads your eye into the distance.

EQUIPMENT
- Rough paper
- Brushes: No. 5, No. 9, No. 12, ½ in (12.5 mm) and 1 in (25 mm) flat
- Cobalt blue, French ultramarine, Old Holland bright violet, cadmium yellow, burnt sienna, cadmium red, Windsor violet, viridian, light red

TECHNIQUES
- Dry brushwork for texture and movement

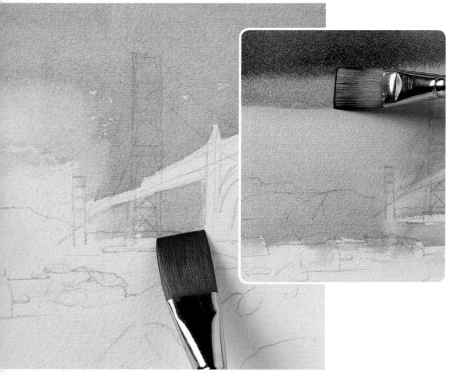
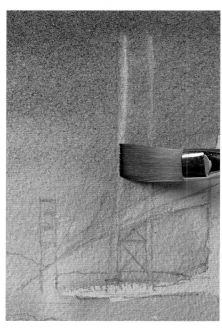
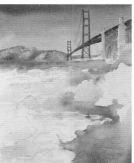

1 Paint the sky and water with a cobalt blue wash using the 1 in (25 mm) brush. Work your way carefully around the bridge on the right-hand side. Add some French ultramarine at the top of the sky with broad strokes, using the same brush. This will turn the flat wash into a varied wash.

2 Wait until the blue wash is quite dry, then use the wet ½ in (12.5 mm) brush to lift out the color from the bridge tower.

BUILDING THE IMAGE

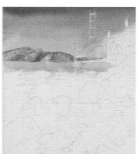
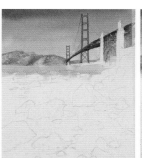
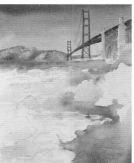

DK WATERCOLOR WORKSHOP II———US EDITION

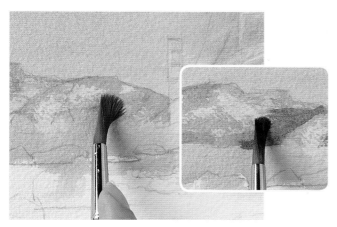

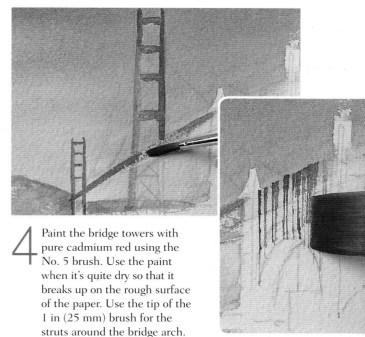

3 Drybrush the outline of the mountains with Old Holland bright violet using the No. 9 brush. Add cadmium yellow to the mountainsides. Use a French ultramarine and burnt sienna mix for the darker areas. Blend in the colors.

4 Paint the bridge towers with pure cadmium red using the No. 5 brush. Use the paint when it's quite dry so that it breaks up on the rough surface of the paper. Use the tip of the 1 in (25 mm) brush for the struts around the bridge arch.

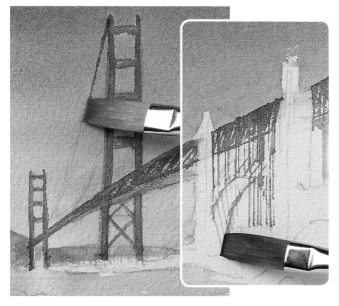

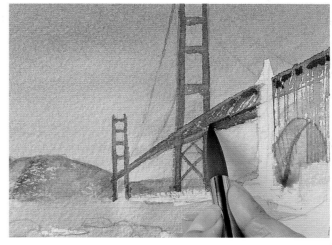

5 Use pure cadmium red on the tip of both the ½ in (12.5 mm) brush and the 1 in (25 mm) one. Alternate the brushes as required for the different sizes of lines in the bridge's supporting structure and suspension wires.

6 Paint the area underneath the arch on the right of the scene with cobalt blue. Add French ultramarine on top of the cadmium red of the bridge to suggest darker, shaded areas. Work it into the distance to create a pleasing lilac.

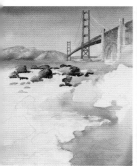
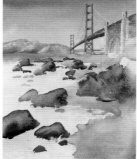
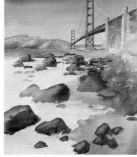
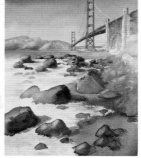
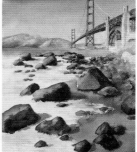

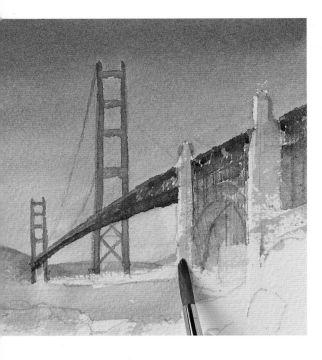

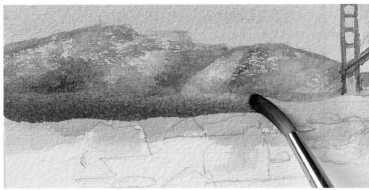

7 Make a beige by mixing Old Holland bright violet and cadmium yellow, and use this color to paint the concrete towers on either side of the arch and the stone structure on the right-hand side. Let the paper's rough texture create a craggy look.

8 Create the shadows at the foot of the hills in the distance with French ultramarine. Using the No. 9 brush, paint the water coming in from the left with a stronger blue, such as pure cobalt blue, which has a sour tinge to it.

"Avoid going into tight, intricate details on the bridge."

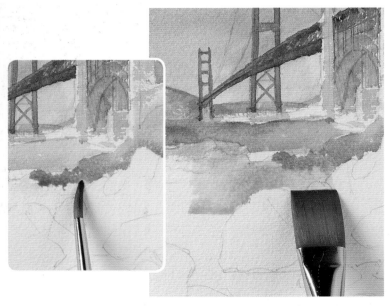

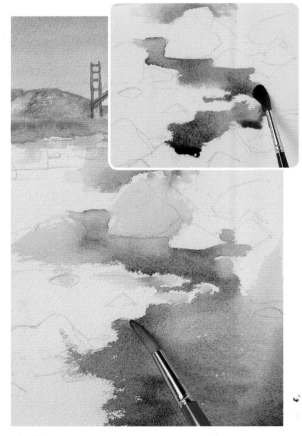

9 Start creating the rocks on the right-hand side of the picture by painting them with French ultramarine using the No. 9 brush. Then use the 1 in (25 mm) brush to blend some cadmium red into the rocky shoreline.

10 Paint the beach at the center of the scene with a sandy mix of burnt sienna and Windsor violet. Use a gray-brown burnt sienna and French ultramarine mix for the beach in the foreground.

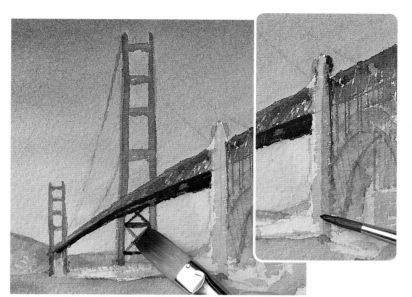

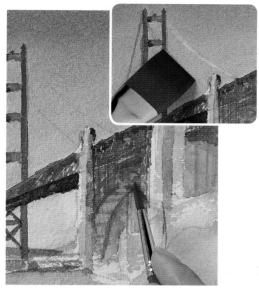

11 Use a cadmium red and French ultramarine mix on the ½ in (12.5 mm) brush for the cross-bracing. Add shadows to the side of the concrete pillars by the arch with French ultramarine using the No. 5 brush.

12 Paint some pure cadmium red around the inner arch of the bridge. Lift out some lines of paint from the sky with the 1 in (25 mm) brush to render the cables.

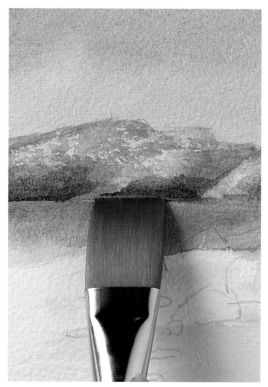

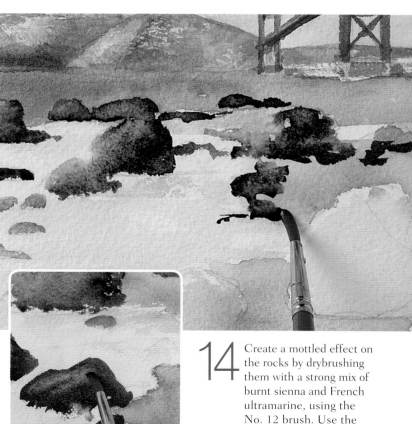

13 Make a mix of Windsor violet and cobalt blue to paint the base of the mountains on the left-hand side. Then blend this color up into the mountains using the 1 in (25 mm) brush.

14 Create a mottled effect on the rocks by drybrushing them with a strong mix of burnt sienna and French ultramarine, using the No. 12 brush. Use the sandy mix from Step 10 for the top of the rocks and to warm the lower right-hand corner of the scene.

> ## SETTING THE SCENE
>
> Remember to link the shapes of all the rocks and their shadows to create a natural feel. This will help emphasize the scale of the foreground and create a vast environment in which to set the structure of the bridge.

15 Apply a bright blue mix of cobalt blue and Windsor violet to create shadows on the rocks in the center and on the left. Use pure cobalt blue for the shadow of the rock at the back jutting out of the water. Create a seaweed mix of viridian and French ultramarine to relieve the blue a little and create the impression of lichen.

16 Lift out some color from the rocks with a damp No. 5 brush. Add texture to the water with a mix of Windsor blue and French ultramarine on the ½ in (12.5 mm) brush, and paint the swirly foam with cobalt blue.

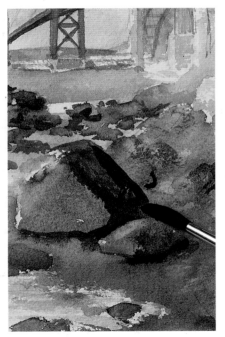

17 Paint the sand between the rocks with the sandy mix from Step 10. Use the gray-brown mix of burnt sienna and French ultramarine to render the sand on the lower left-hand side of the scene, between the rocks.

18 Tidy up the shadows with the No. 5 brush. Use the gray-brown mix for the pile of sand below the concrete structure on the right. Use the seaweed mix from Step 15 for the area where the rocks sink into the sand.

19 Apply a dark bluish mix of French ultramarine and light red to the dark areas and shadows of the horizontals under the arch, using the No. 5 brush.

Golden Gate Bridge ▶

The Golden Gate Bridge is such a powerful, dominant subject that the rest of the painting has been structured around it. The blues in the painting have been kept pure to complement the orange-red of the bridge and make it stand out.

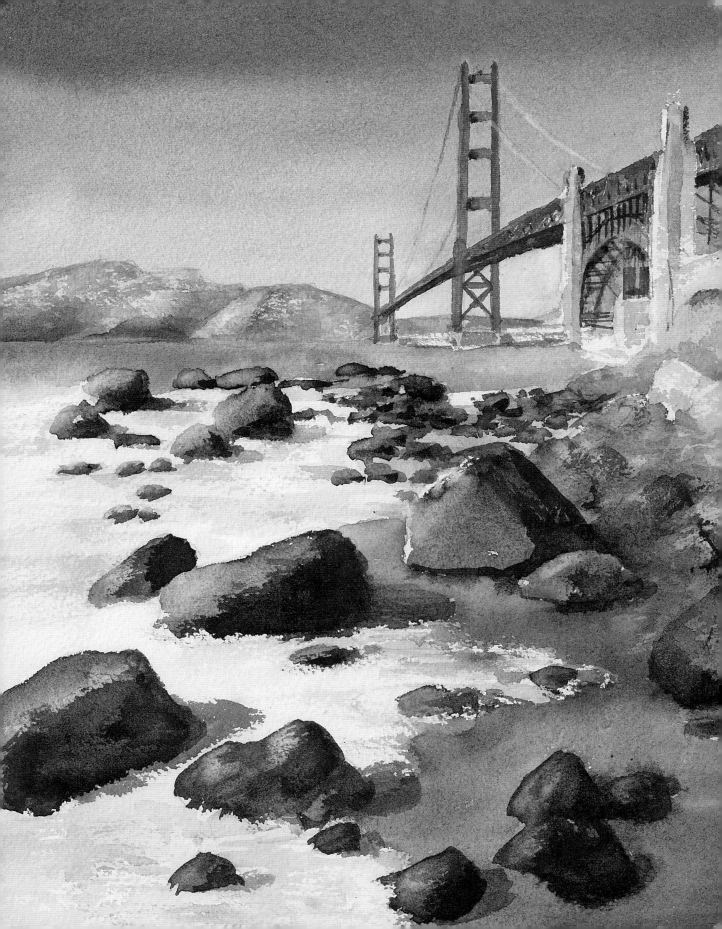

③ Boats on a lake

In this painting, gradation is used to create the impression of distance and calm. The sky's smooth transition from dark (warm) to light (cool) guides the eye down to the horizon line and helps to suggest distance. Color and tonal gradation continue in the trees and foliage, as well as on the water's surface. The vertical tree trunks and posts interrupt the color transition, while the limited use of red and orange abruptly captures the attention, separating and balancing the graded areas. The pure white divides the foreground and focuses interest on the near boat.

EQUIPMENT
- Rough paper
- Brushes: No. 5, No. 6, No. 9, No. 12, ½ in (12.5 mm) and 1 in (25 mm) flat, squirrel, sable
- French ultramarine, cobalt blue, cerulean blue, raw sienna, sap green, burnt umber, Windsor violet, cadmium orange, emerald green, cadmium yellow, cadmium red

TECHNIQUES
- Dry brushwork
- Splattering

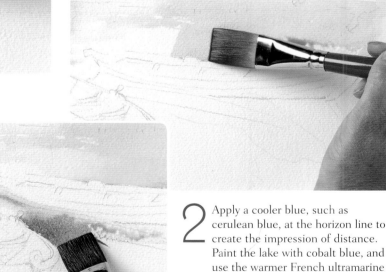

1 Wet the paper with water on a clean brush. Apply a French ultramarine graded wash at the top of the picture area with the 1 in (25 mm) flat brush. Use cobalt blue for the horizon line. Lift out color with a dry tissue to create clouds.

2 Apply a cooler blue, such as cerulean blue, at the horizon line to create the impression of distance. Paint the lake with cobalt blue, and use the warmer French ultramarine to pick out the division between the two boats, as well as for the water on the side of the boat on the left.

BUILDING THE IMAGE

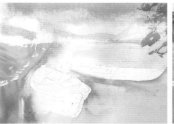

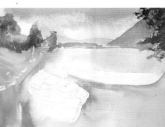

3 Using the No. 12 round brush, paint in a stronger layer of cobalt blue just above the cerulean blue horizon line to create the shape of the mountains in the far distance. Allow this layer to dry before continuing.

4 Use the same brush to apply strokes of raw sienna. This staining pigment will provide a glow running through the middle of the painting. Raw sienna is yellow, but when used straight on wet and mixed with blue, it turns green.

5 Paint the banks of the lake with sap green on the No. 12 brush. With the 1 in (25 mm) brush, sweep sap green and raw sienna on the right-hand side, creating the bottom of the boat by painting around it. This technique is called negative painting.

6 Use a dry brush to mix sap green and raw sienna. Use the drybrush technique to paint in rough foliage: dragging your brush over the dry paper's surface will produce broken marks.

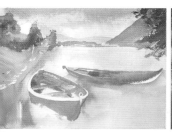

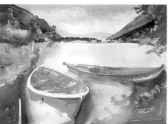

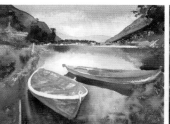

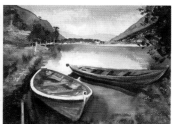

7 Paint in the trees on the left with a mix of sap green and cobalt blue. Use the No. 12 and the 1 in (25 mm) brushes for the edges of the trees.

"Use color and tonal gradation to create unity and drama."

8 Use the dry brushwork technique for rendering the foliage of the trees. Paint the leaves with the No. 5 brush and a mix of burnt umber and French ultramarine.

9 With the No. 12 brush, add some Windsor violet to the area above the boat on the right. Paint the hulls of the two boats using a mix of Windsor violet and burnt umber for the one on the right, and pure Windsor violet for the one on the left.

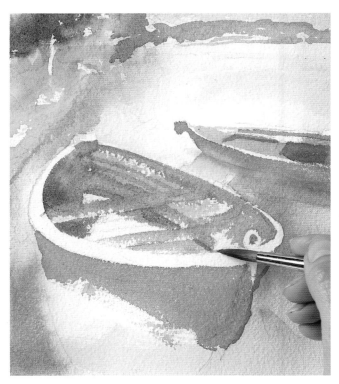

10 Mix Windsor violet and raw sienna for the inside of the boat on the right, and raw sienna with a little sap green for the one on the left. Create water reflections in the boat with French ultramarine and the No. 5 and No. 6 brushes.

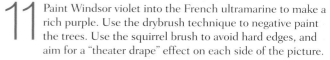

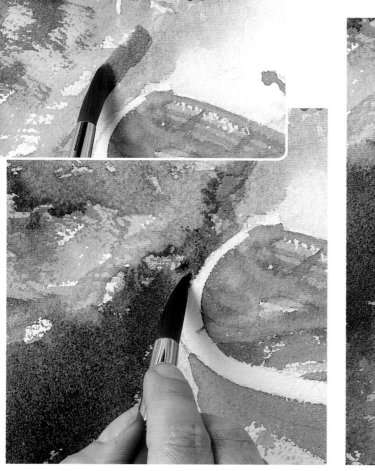

11 Paint Windsor violet into the French ultramarine to make a rich purple. Use the drybrush technique to negative paint the trees. Use the squirrel brush to avoid hard edges, and aim for a "theater drape" effect on each side of the picture.

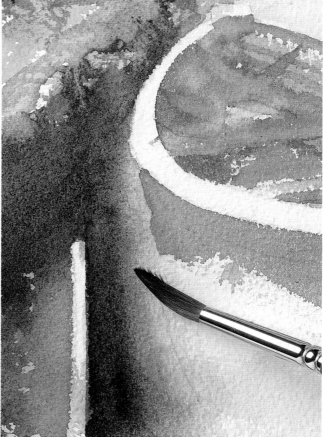

12 Strengthen the greens in the background. Use a mix of sap green, raw sienna, and French ultramarine for the trees. Suggest the riverbank with burnt umber. Add burnt umber to the rich purple to paint the edge of the left-hand boat.

13 Use a mauve mix of Windsor violet and French ultramarine at the side and bottom of the left-hand boat. Soften and gradate it with the sable brush. Use the same mix to strengthen the color between the two boats.

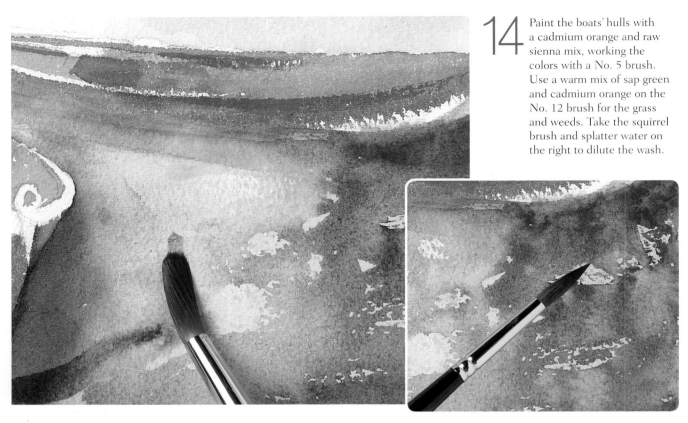

14 Paint the boats' hulls with a cadmium orange and raw sienna mix, working the colors with a No. 5 brush. Use a warm mix of sap green and cadmium orange on the No. 12 brush for the grass and weeds. Take the squirrel brush and splatter water on the right to dilute the wash.

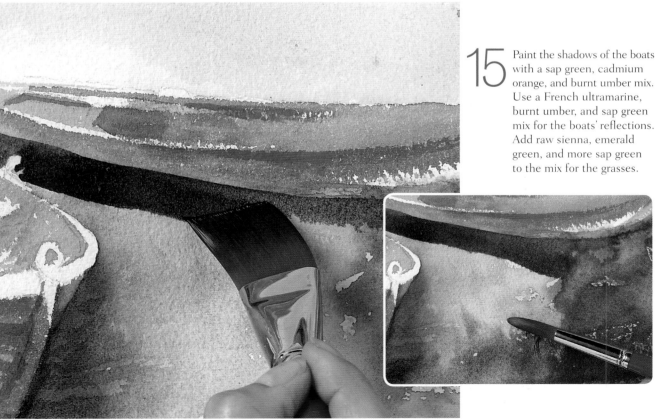

15 Paint the shadows of the boats with a sap green, cadmium orange, and burnt umber mix. Use a French ultramarine, burnt umber, and sap green mix for the boats' reflections. Add raw sienna, emerald green, and more sap green to the mix for the grasses.

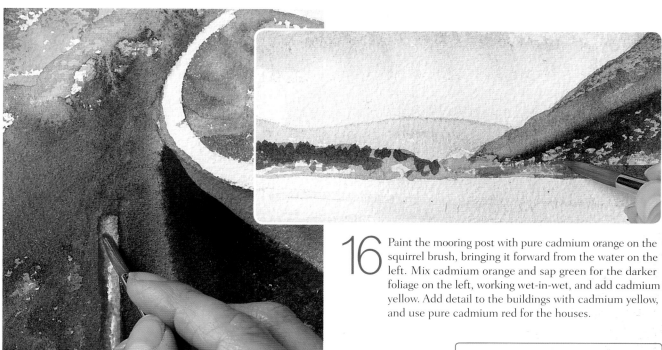

16 Paint the mooring post with pure cadmium orange on the squirrel brush, bringing it forward from the water on the left. Mix cadmium orange and sap green for the darker foliage on the left, working wet-in-wet, and add cadmium yellow. Add detail to the buildings with cadmium yellow, and use pure cadmium red for the houses.

PERSPECTIVE EFFECT

By using stronger colors in the foreground and more muted colors in the distance, it is possible to create the impression of perspective. In this painting, the effect is like that of the inside of a drum, or barrel, with the top and bottom of the work comprising the elements that are closest to the viewer, and the horizon line, in the center of the painting, the part that seems farthest away.

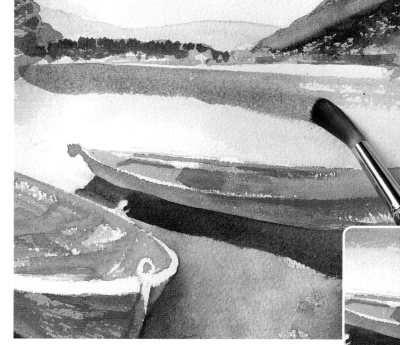

17 To create the reflections of the sky in the water, apply cobalt blue with horizontal strokes of the No. 12 brush. Bring the right-hand side forward with the rich-purple mix.

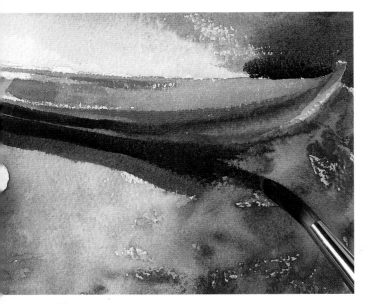

18 Define the outer edges of the boats with a mix of Windsor violet and burnt sienna, using the No. 5 brush. Use cadmium orange for their bases. Mix sap green and burnt umber to strengthen the area between the boats.

19 Create shadows around the boats with a mix of French ultramarine, Windsor violet, and burnt sienna. Use a sap green, burnt umber, and burnt sienna mix for the edge of the bank, and a little cadmium yellow for highlights.

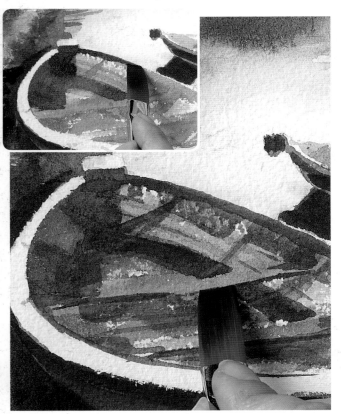

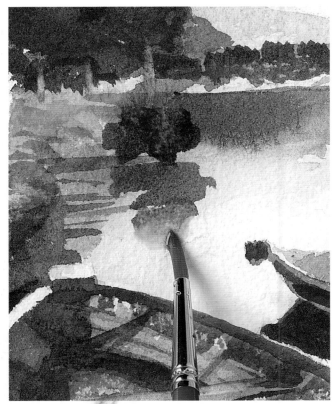

20 Paint the inside of the left-hand boat with a mix of burnt sienna and Windsor violet. Apply pure burnt sienna with the ½ in (12.5 mm) flat brush to bring some elements forward.

21 For the reflection of the tree on the water, apply a mix of sap green and burnt umber with a No. 5 brush. Use a mix of Windsor violet and burnt umber for the horizon line between the tree and its reflection.

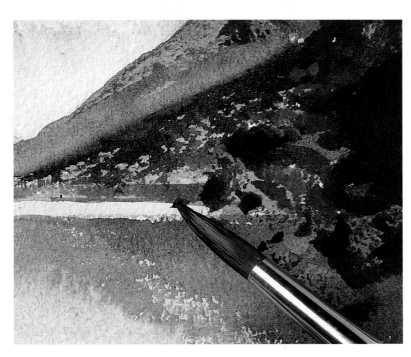

22 Use the sap green and burnt umber mix for the foliage of the tree on the right. Put in any final details, such as on the horizon, with the No. 12 brush, which you can also use to brighten up any colors that require it.

▼ Boats on a lake

The graded color scheme, using a subtle variation of different blues, unifies the whole picture area in this painting, producing a harmonious, calm scene. This common blue component makes it easier for the viewer's eye to move through the composition.

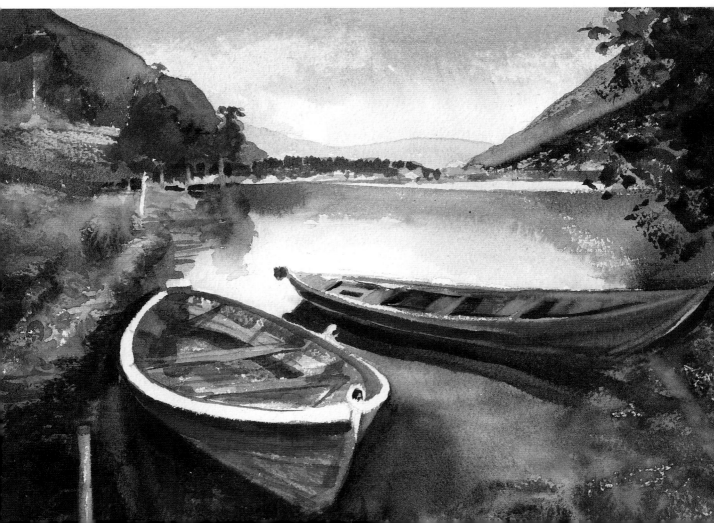

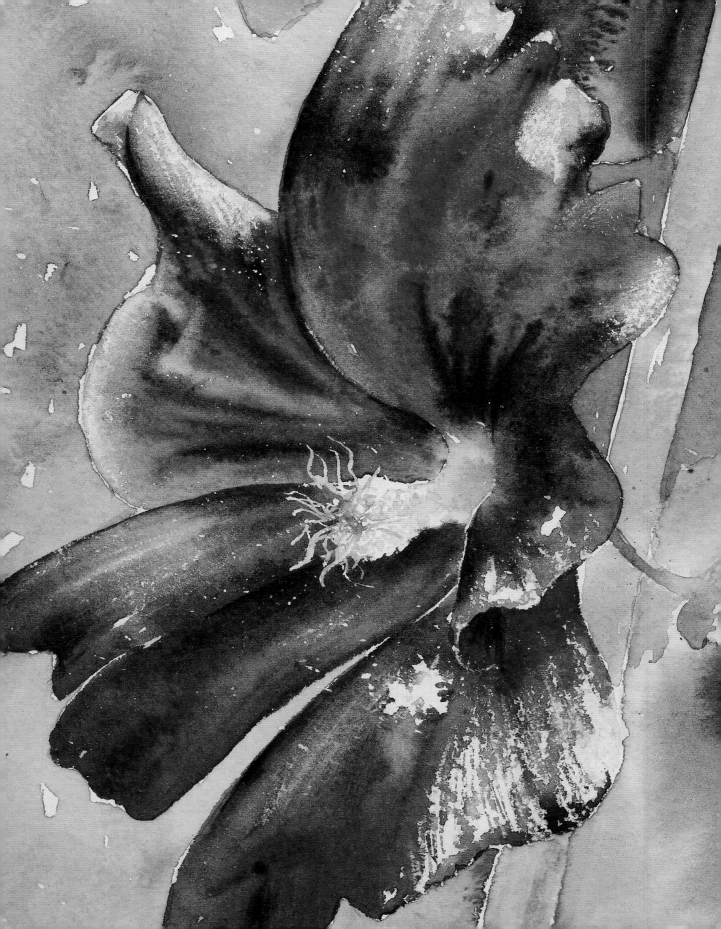

Still Life

"Take time to consider the beauty of small things."

Still life

One of the advantages of still-life painting is that the subjects stay still. This is great when working with watercolor, since you can let the painting develop without feeling rushed. When starting a still-life painting, look at how the shapes relate to each other, and try to see the movement and direction within the grouped objects. Your painting need not be stilted just because the subject is stationary.

LINKING SHAPES

The directions through a painting can have a great effect on the mood evoked in a viewer. Sometimes a subject will allow you to impose a direction on it, linking elements to form a more interesting scene. By deciding on a dominant direction, you can shape the composition, and once you have decided on the composition, you can move elements to fit better into the design.

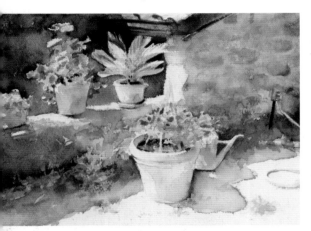

Potted plants and watering can In this study of a charming little corner of a garden, the structure of the wall has produced a strong diagonal direction. In the illustration on the right, however, you can see how this direction is counterbalanced by the positions of the pots.

The flowerpots on top of the wall create an inward line.

The large pot is linked to the watering can for focus.

FLOWING RHYTHM

The shapes, colors, patterns, and lines used in a painting produce a visual pathway through it. This is known as rhythm, and it is an essential element of a well-structured composition. Rhythm keeps the eye moving and stops your work from being stilted and boring. A visual pathway can also be used to control the viewer's eye movements, directing them to a key point in the picture.

The spiral creates a pathway through both figures.

Cupids This subject is set against a plain background, so the painting needs a strong sense of rhythm. In creating this work, it was important to choose an angle that best showed the connection and unity between the two figures. The red line defines the rhythm that links the legs to the heads, arms, and faces of the cherubs.

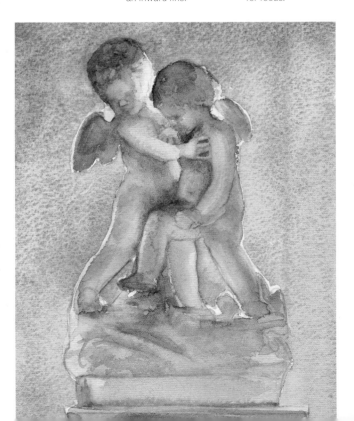

USE OF COLOR

The simpler the subject, the greater the need to make the painting strong. Composition is of prime importance, but in a picture with very little actual structure, you can use color to great effect. In this painting, careful attention has been paid to the pattern and design within the blooms, while the red tulip contrasts with the dominant yellow tulips to create a visually dynamic study.

The visual pathways are directed around the painting so that the viewer's eye cannot wander off the edges. Each time you follow a direction, you are forced to linger awhile in one area before moving off along another track.

The red tulip attracts the viewer's attention.

The yellow flowerheads are linked together.

Tulips With such simple subject matter, it is important to create visual interest within the design. This has been achieved by directing the eye through each bloom with a soft, lyrical rhythm. The rhythm is halted at the edges by a strong diagonal on the right of the painting and a contrasting color on the left.

Gallery

Still-life subjects can be found all around you, and watercolor is a fluid and flexible enough medium to be able to handle them all.

Composting quinces ▶

This found-object subject, a compost heap, has given rise to a vibrant still life. The color scheme of bright reds and vivid oranges against submissive pale green makes this a striking composition. *Carole Robson*

▼ Harebells and poppies

The close-up detail of the flowers in this painting has contributed to a vibrant, powerful work of loosely handled color. The background has been ignored to keep the focus on the large red poppies. *Emile Nolde*

▲ Study in white

Initially, this seems to be quite a simple picture of two mugs and a tube of paint. However, the shadows of the napkins have been painted in an abstract manner, lending strength to the whole composition. These shadows give the painting direction and rhythm. *Sara Ward*

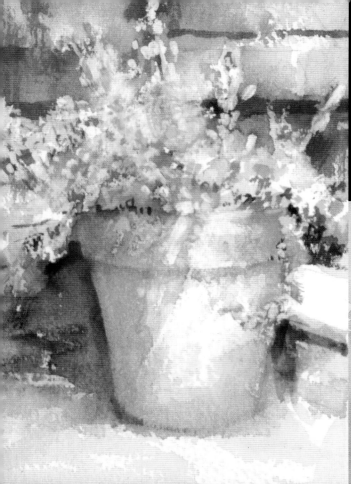

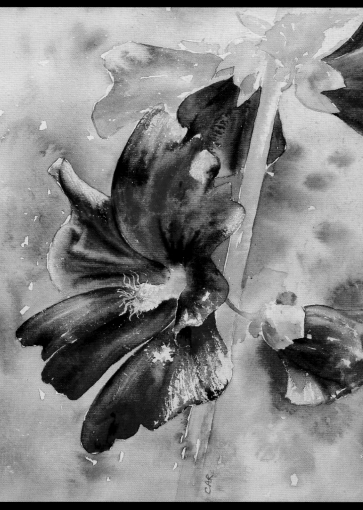

◀ **Lavender**

A small found subject in the corner of the garden led to a lively study of a flowerpot with lavender. The colors of the plant have been grouped together from yellow to green and blue, energetically lifting away from the calm, warm tones of the brick wall. *Glynis Barnes-Mellish*

◀ **Orchids**

Flowers offer the opportunity to use a full range of watercolors. The side lighting has perfectly described the delicate, papery petals, while the strong dark tones in the background help focus attention on the light and the reflections of the glass vase. *Glynis Barnes-Mellish*

▲ **Black hollyhock**

This painting uses the wet-in-wet technique to great effect in rendering the flowers, resulting in a soft, velvety appearance. The reds and purples are intensified by the use of complementary greens in the stem and the background. *Carole Robson*

4 Garden table

Interlocking shapes and contours are used to create the underlying structure of this painting, uniting the various elements of the picture and creating a sense of rhythm. The recurring shape here is the ellipse, which always has to be drawn accurately so that it doesn't attract attention for the wrong reasons. Ellipses don't need to be rigid – just balanced, so that they look like circles seen from an angle. To check that both sides of an ellipse are the same, try looking at it from different viewpoints: this will expose any unevenness.

EQUIPMENT
- Rough paper
- Brushes: No. 5, No. 8, No. 9, No. 12, ½in (12.5 mm) and 1 in (25 mm) flat, squirrel
- Cerulean blue, cadmium yellow, French ultramarine, gamboge, emerald green, alizarin crimson, Old Holland brilliant pink, Windsor violet, light red, cadmium orange, cadmium red, burnt umber, burnt sienna, viridian

TECHNIQUES
- Wet on dry
- Dry brushwork

1 Start with a unifying cerulean blue wash, using the 1 in (25 mm) brush. Draw in some of the key lines with one stroke. Paint over the background with a mix of cadmium yellow and a little French ultramarine to make it green.

2 Use gamboge on the No. 12 brush for the sunny side of the pots. Apply emerald green in one stroke to the shears' handles and the seed packet. For the gloves, use an alizarin crimson and Old Holland brilliant pink mix, and blend it in.

BUILDING THE IMAGE

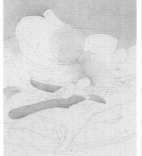 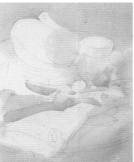 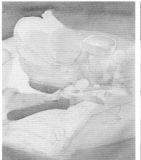 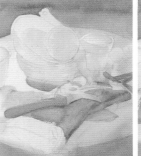 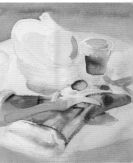

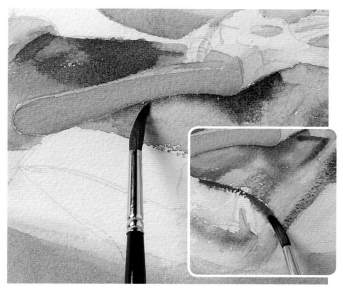

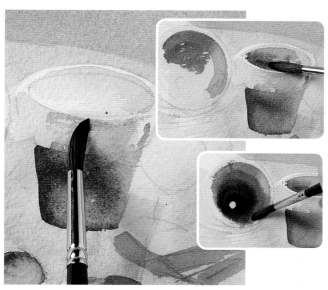

3 Paint alizarin crimson at each side of the shears to give a lilac shadow. For the gloves, blend in a mix of alizarin crimson and Windsor violet with the squirrel brush. Add creases and detail with pure alizarin crimson, using the No. 9 brush.

4 Mix light red with a tiny amount of French ultramarine for the small pot on the top right of the picture. Use this same mix for the insides of the two small pots. Blend cadmium orange into the yellow on the rim of the small, top-right pot.

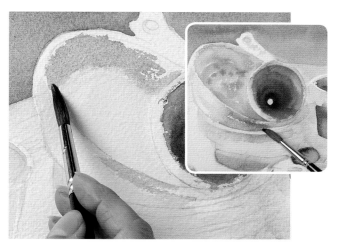

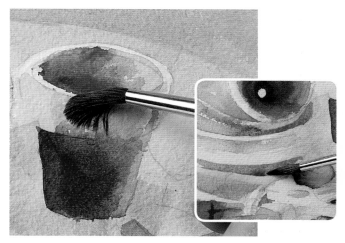

5 Use a light red and cadmium orange mix inside the upper-left pot. While it is still wet, paint over it with cerulean blue, then add spots of the light red and cadmium orange mix, using the tip of the No. 9 brush.

6 Use the mix of light red and cadmium orange for the left side and inside of the pot on the right. Mix cadmium red and cadmium orange for the ellipse of the largest pot in the centre. Add cerulean blue to the edges of the central pots.

 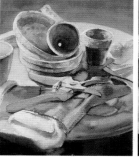 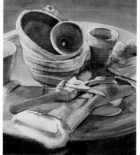

7 Use the ½ in (12.5 mm) brush to apply a mix of gamboge and French ultramarine to the area between the pot on the left and those in the center. Paint the shadows on the shears' handles using the same mix and brush. Define the trowel handle with a mix of gamboge and alizarin crimson.

8 Paint the front of the table with the gamboge and French ultramarine mix, this time using the 1 in (25 mm) brush. The result is different from that achieved in Step 7 because the underlying color is different. Blend with the No. 12 brush. Use burnt umber, on the No. 8 brush, to bring forward the upper and lower edges of the table.

9 Apply pure French ultramarine to the shears' blades, and burnt umber to the lower edge of the top blade. Use cadmium orange, on the No. 5 brush, around the bolt, and a mix of French ultramarine and burnt sienna for the bolt and spring.

10 Use light red on the 1 in (25 mm) brush for highlights both outside and inside of selected pots. Blend with the ½ in (12.5 mm) brush. Apply a cadmium orange and cadmium red mix to the exteriors of the central pots.

11 Mix gamboge and light red for the bulbs on the right. Paint over the blue on the seed packets on the right with cadmium red. Use the French ultramarine and burnt sienna mix for the seam of the thumb on the glove.

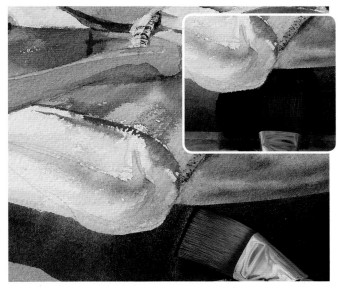

12 Paint the dark grass at the bottom with a viridian and burnt umber mix, using the 1 in (25 mm) brush. Use Windsor violet for the table legs. Add an emerald green and cadmium yellow mix to the upper background.

RETOUCHING

When retouching areas of a painting, such as these pots, it is easy to overdo it. To make the pots look old, it is important to create the right feel without overworking them.

13 Age the central pots with a mix of burnt sienna, light red, and cadmium orange. Ground the right pot with a French ultramarine and Windsor violet mix around the base. Darken the top pot with a Windsor violet and light red mix.

14 Darken the edges of the shears with a burnt umber and French ultramarine mix. Use French ultramarine, on the tip of the No. 8 brush, to separate the pots from the shears. Add viridian to the shears' handles.

15 Create a shadow to the right of the glove by applying broad strokes of French ultramarine with the ¹/₂ in (12.5 mm) brush.

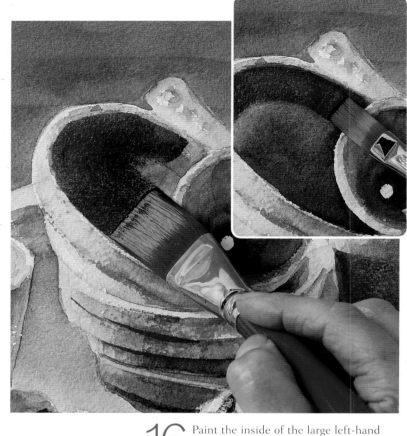

"Separate two areas of similar tone by making them different in color."

16 Paint the inside of the large left-hand pot with a mix of light red and French ultramarine, using the 1 in (25 mm) brush. Once it has dried, lighten the edge of the base. Add the same mix to the inner wall of the same pot, sweeping it around with the ¹/₂ in (25mm) brush. Inside the right-hand pot, use Windsor violet on the No. 5 brush.

17 Add the finishing touches across the painting. Add in a little emerald green on the shears' handles, near the bolt. Define the hole in the trowel handle with the emerald green and cadmium yellow mix, using the No. 5 brush. Apply burnt umber to the trowel handle. Tidy up the ellipses, such as the top lip of the central pot, with Windsor violet.

Garden table ▶

Circles and ovals are always pleasing to look at because they are such simple shapes. The pivotal point of this painting is the small pot shown as a full circle. All the other pots form interconnecting ellipses supporting the central pot.

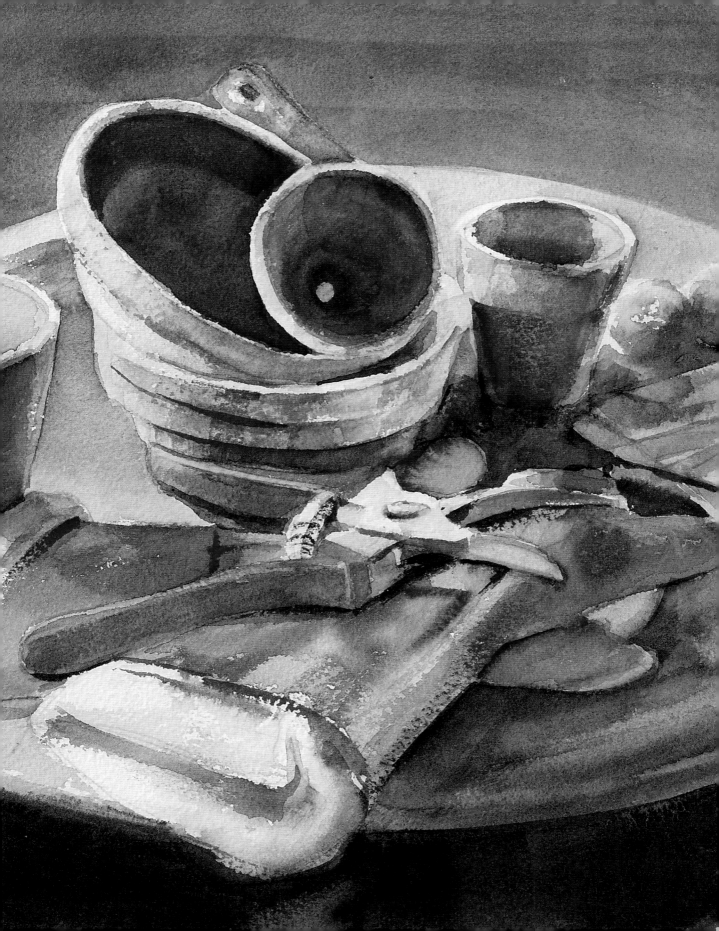

5 Jug with lilacs

At first glance, this subject looks complicated, but the secret is to find a common factor: an initial wash of cadmium yellow establishes the tonal structure and unites the different elements of the picture. It is easier to paint around the few petals in full light, which need to remain white, if you use a wax resist. This will give you free rein to mix the colors directly on the paper, so that you can keep them luminous but well blended. Creating a harmonious range of tones will stop the flowers from looking too formal or stiff.

EQUIPMENT

- Cold-pressed paper
- Brushes: No. 5, No. 9, No. 12, ½ in (12.5 mm) and 1 in (25 mm) flat, squirrel
- Cadmium yellow, Old Holland bright violet, cerulean blue, Old Holland green, Hooker's green, alizarin crimson, burnt umber, raw umber, French ultramarine, light red
- Wax

TECHNIQUES

- Wax resist
- Glazing

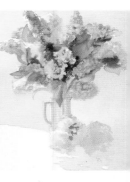

1 Make your initial pencil sketch and apply wax to any areas of the paper that are to remain white in the finished painting – for example, on the flowers and on the area between the jug and its handle. This is known as a wax resist.

2 Paint a cadmium yellow wash using the 1 in (25 mm) brush. Use this wash even on what will become the lilac-colored flowers on the right-hand side of the scene, but not on those on the left. You will not get a rich, pleasing lilac if these areas are covered in yellow.

BUILDING THE IMAGE

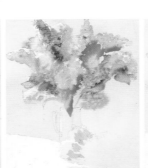

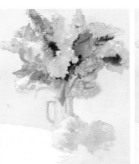

3 Paint the flowers that have been left white with Old Holland bright violet using the No. 12 brush. Use this color on the other lilac flowers too, over the wet yellow wash. This will change the yellow into a soft pink.

4 Use cerulean blue on the yellow area below the main lilac flower to make a green. Paint the flowers at the top center of the scene with Old Holland green. This reacts to the wash below and becomes a rich yellow.

5 Drop water on the lilac flower to create the balloon effect of the petals. Use the No. 9 brush with cerulean blue to make the petals of the yellow flowers. Dab and lift out as necessary.

6 Paint the stems and leaves with a midrange green, such as Hooker's green, using the No. 9 brush. These green elements anchor the scene, bringing the other colors together. Add definition to the flowers.

7 Paint the flowers lying below the jug with cadmium yellow. Add some cerulean blue while the yellow is still wet to create a secondary shade of green. Push the yellow over to the left-hand, sunny side of the scene.

8 Use the squirrel brush to blend alizarin crimson on the yellow to create the jug's round, shiny, hard shape. Add some cerulean blue to the jug handle to make a green color. Keep the edges soft and matte.

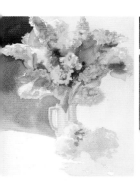
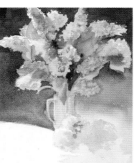
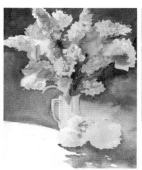
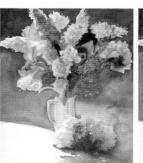

9 Paint the leaves of the flowers on the mid left-hand side of the picture with a lime-green mix of Hooker's green and cadmium yellow, using a No. 5 brush. Use the ballooning technique from Step 5 to render the petals.

10 Create a darker green by mixing Hooker's green and burnt umber. Use this color to negative paint the flowers. This means creating the shape of the flowers by painting the area around them. Be careful not to overpaint.

11 Use the tip of the No. 5 brush to paint the petals on the yellow flowers with a burnt umber and cadmium yellow mix. Create warm shadows on the flowers with a mix of raw umber and Old Holland bright violet.

"The brighter the light source, the lighter the shadows should be."

12 Paint the background on the left with a mauve-gray mix of French ultramarine and light red, using the 1 in (25 mm) brush. Blend well. Add some cadmium yellow to the mix as you come down the paper to render sunnier areas.

13 Add some of the mauve-gray mix to the top of the picture, using the 1 in (25 mm) brush. This will make the flowers stand out. As you come down into the flowers, switch to the No. 5 brush.

14 Define the leaf on the right by painting around it with the mauve-gray mix, using the 1 in (25 mm) brush. Add some cadmium yellow to the mix to outline the shape of the lilac flowers on the right.

15 Add some light cadmium red to the mix as you come forward into the scene. Negative paint the flowers near the jug using the 1 in (25 mm) brush. As objects move away from direct shadow, they get a paler, softer effect.

16 Use the squirrel brush to dab some Old Holland bright violet onto the main lilac flower. It is best to use this color dry, otherwise it could spread excessively. Leave the shapes soft and undefined.

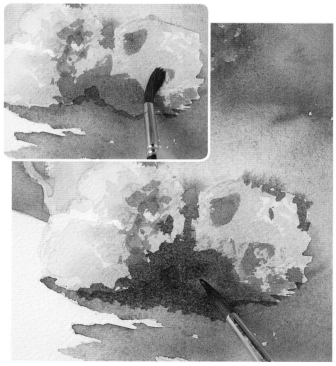

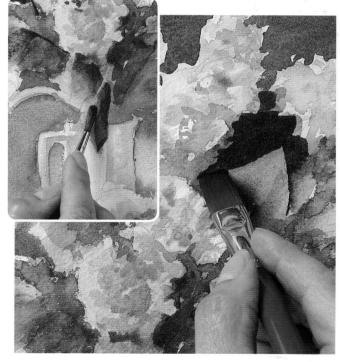

17 Paint the flowers to the right of the jug with a mix of Hooker's green and cadmium yellow. Create a textural effect with another, warmer, green mix of Hooker's green and burnt umber. Soften with the squirrel brush.

18 Negative-paint and define the shapes of the petals with the same warm green mix. Use the ½ in (12.5 mm) brush. Blend the color in well with the No. 5 brush.

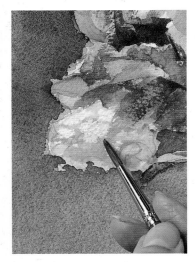

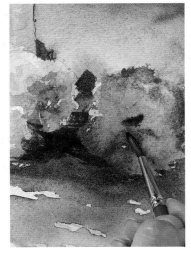

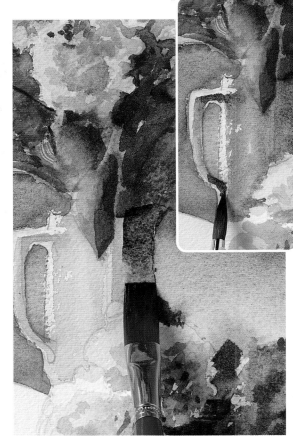

19 Paint the lowest flower in the vase, on the left-hand lower side, with an acid-green mix of Hooker's green and cadmium yellow. Use the No. 5 brush.

20 Return to the flowers below the jug. Paint their dark areas with the Hooker's green and burnt umber mix. Then use the same mix in the central areas.

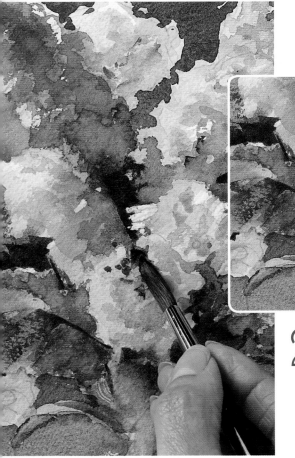

21 Paint the right side of the jug with a French ultramarine glaze using the ½ in (12.5 mm) brush. Soften the glaze with the squirrel brush and use it around the handle of the jug, too. Use the mauve-grey mix on the top and bottom of the jug handle. Dip the ½ in (12.5 mm) brush in water and use it to take out the central line of the jug. Leave to dry.

22 Paint the leaves to the right of the jug and at the center of the scene with the Hooker's green and burnt umber mix. Use the same mix with the squirrel brush to darken the foliage on the right-hand side of the painting. Soften the edges with a little water.

Jug with lilacs ▶

The dramatic areas of white created with the wax resist convey the strength of the light pouring in from the left. The soft, fluid effect characteristic of watercolors has successfully captured the delicate, intermingling tones of the flowers.

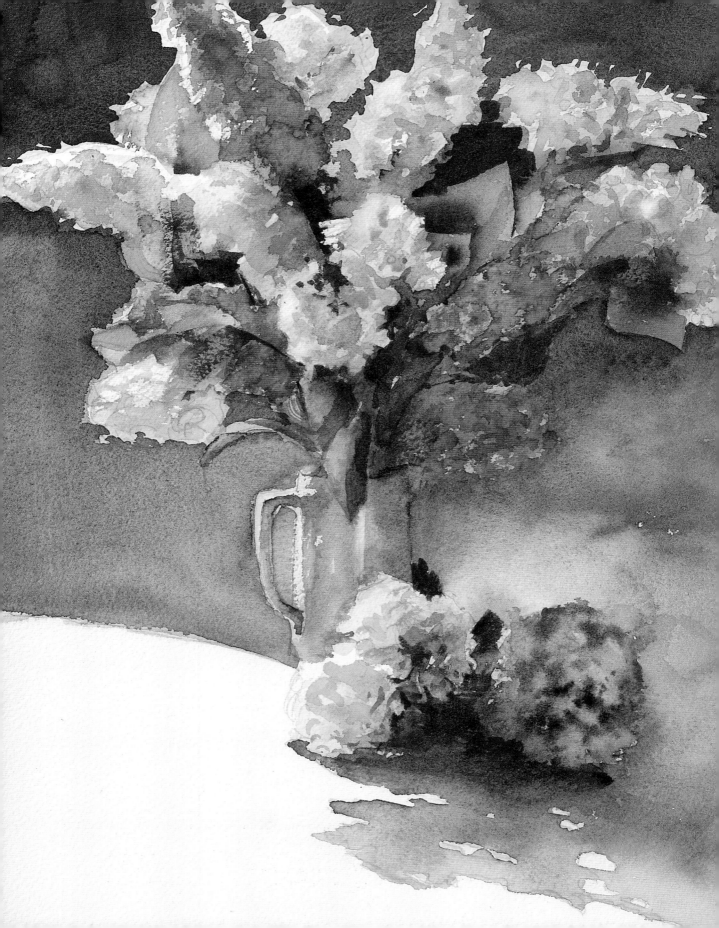

6 Baskets of fruit

Vibrant color is the most striking feature of this study of summer berries. Since each basketful of berries is painted as one object, rather than as individual pieces of fruit, they are identified principally by their colors (reds and blues). The hues used in the rest of the painting therefore need to be complementary to them (greens and yellows). The soft forms of the berries are contrasted with the sharp lines of the baskets, and the symmetry of the foreground is broken up by the berries of various sizes scattered on the ground.

EQUIPMENT
- Rough paper
- Brushes: No. 1, No. 5, No. 9, No. 12, ½in (12.5 mm) and 1 in (25 mm) flat, squirrel
- Alizarin crimson, French ultramarine, cadmium red, Old Holland gamboge, cobalt blue, cadmium yellow, raw umber, Old Holland turquoise blue deep, burnt umber, Windsor violet

TECHNIQUES
- Wet in wet
- Lifting out

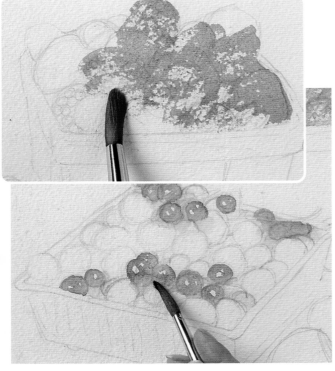

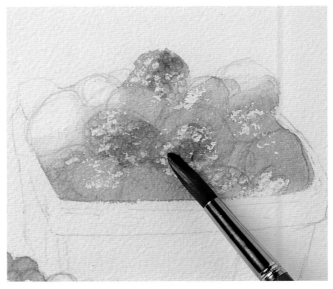

1 Paint the fruit on the right of the top basket and the cherries in the bottom basket with alizarin crimson, using the No. 12 brush. This cool base will give the fruit a pleasing shine. Blend it in. Create highlights by leaving some white areas.

2 Soften the edges of the individual fruits. Use alizarin crimson on the strawberries outside the lower basket, and French ultramarine on the blackberries in the top basket, on the No. 12 brush. Painting blue on pink makes a lilac.

BUILDING THE IMAGE

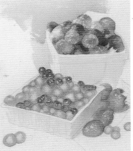
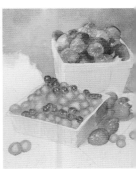

3 Paint the blueberries in the lower basket with French ultramarine using the No. 12 brush. Add a little water with the No. 9 brush to obtain a ballooning effect and create the shapes of the individual fruits.

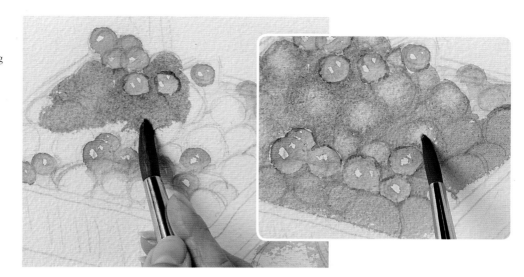

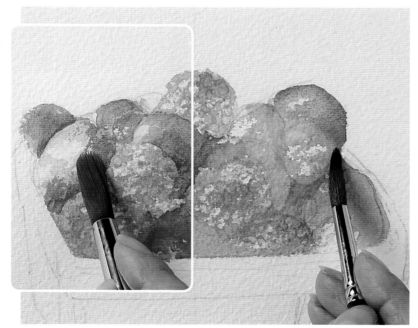

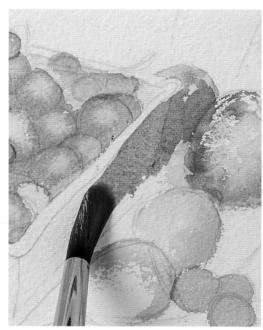

4 Focus on the top basket next. Paint the fruit on the top left with cadmium red on the No. 12 brush, then add Old Holland gamboge on top. The resulting warm orange-yellow mix will isolate the pink. Use the same mix on the top right-hand corner. Soften the colors with a damp brush.

5 Use cadmium red on the right-hand side of the lower basket to suggest reflections of the color from the strawberries. Paint these with pure gamboge, then add some cadmium red.

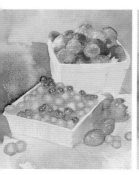
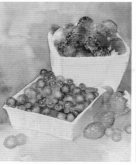
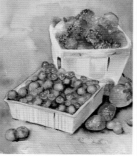
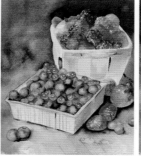
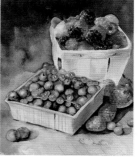

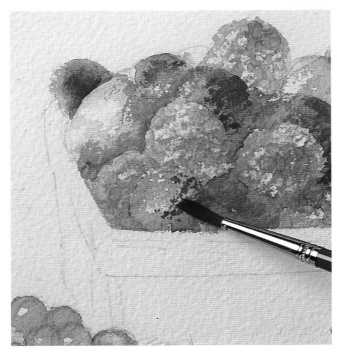

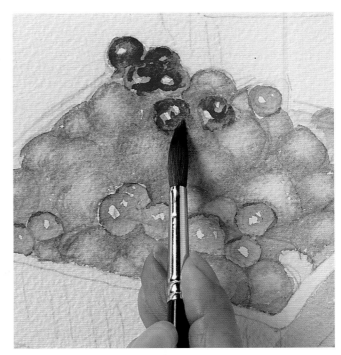

6 Make a cooler red by mixing alizarin crimson and cadmium red. Use this color and the No. 5 brush to paint shadows on the fruit in the left-hand side of the top basket, as well as for the strawberries on the right-hand side.

7 Paint around the redcurrants in the bottom basket with pure cadmium red on top of the pink, using the No. 5 brush. This layering of colors allows the pink highlights to come through. Soften with the squirrel brush.

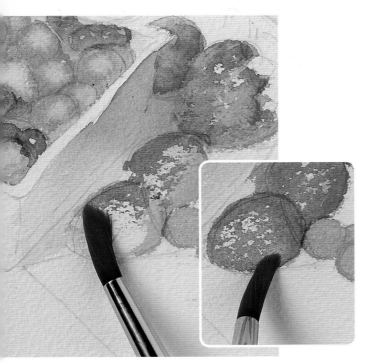

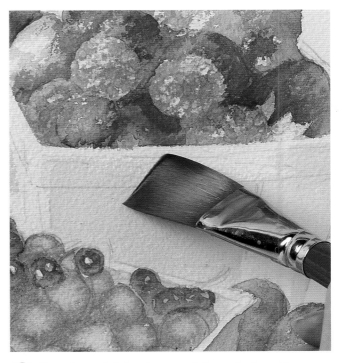

8 Drybrush the seeds on the strawberries at the bottom right of the bottom basket with pure cadmium red using the No. 12 brush. Paint the shaded side of the strawberries using the same color. Let the paint dry.

9 Paint the top left-hand corner of the top basket with gamboge, using the 1 in (25 mm) flat brush. Use the same color on the front of the top basket, the front right-hand side of the lower basket, and the area behind the basket.

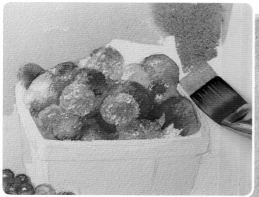

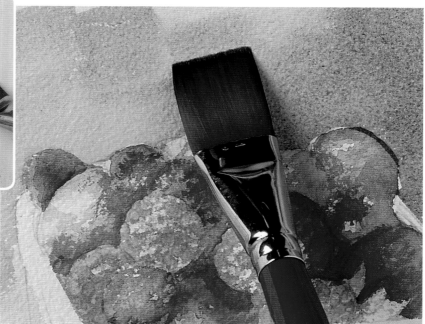

10 Paint the top right-hand side of the picture with a green mix of French ultramarine and gamboge, using the 1 in (25 mm) brush. Apply this mix in strokes on to the yellow in the top center, to the left of the top basket, and on the right-hand side of the bottom basket.

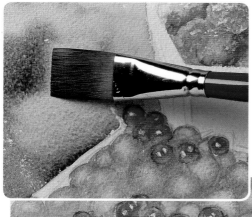

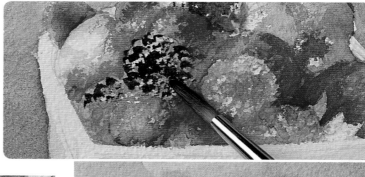

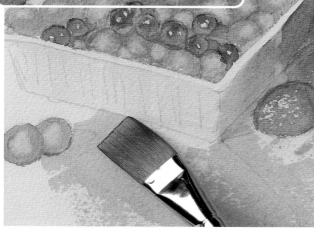

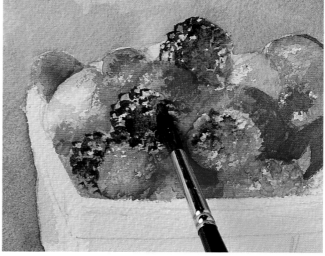

11 Paint the area to the left of the top basket with a French ultramarine, gamboge, and cadmium red mix, using the 1 in (25 mm) brush. Use a gamboge and cadmium red mix on the table and at the bottom of the picture. Blend it in.

12 Paint the top basket's blackberries with a mix of French ultramarine and alizarin crimson. Use the tip of the No. 9 brush and the roughness of the paper to define the berry forms. Strengthen the raspberries with cadmium red.

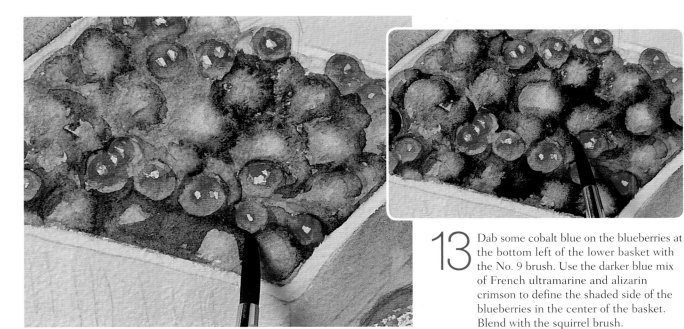

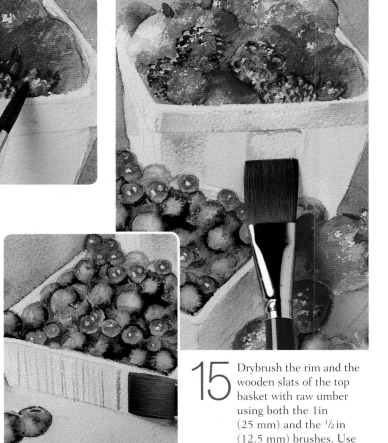

13 Dab some cobalt blue on the blueberries at the bottom left of the lower basket with the No. 9 brush. Use the darker blue mix of French ultramarine and alizarin crimson to define the shaded side of the blueberries in the center of the basket. Blend with the squirrel brush.

GROUP STUDY

The trick in a painting like this is to treat the fruit as a group and not be sidetracked by intricate details on individual berries. By keeping the berries soft and loose in feel, you create a more interesting painting.

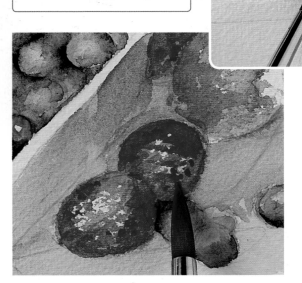

14 Strengthen the strawberries outside the basket with cadmium red and alizarin crimson on the No. 12 brush. Paint the bottom right and top left of the top basket, as well as the strawberry leaves, with a soft green mix of cadmium yellow and cobalt blue, using the No. 9 brush.

15 Drybrush the rim and the wooden slats of the top basket with raw umber using both the 1in (25 mm) and the ¹/₂ in (12.5 mm) brushes. Use the No. 1 brush on the lower basket to render its wooden structure.

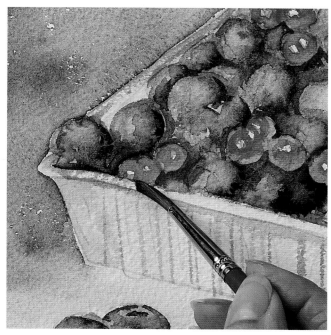

16 Use the green mix from Step 10 along the rim of the top basket and on the right-hand side of the bottom basket. Use the 1 in (25 mm) brush for these details.

17 Paint the length of the rim of the lower basket with a bright color such as Old Holland turquoise blue deep, using the No. 5 brush.

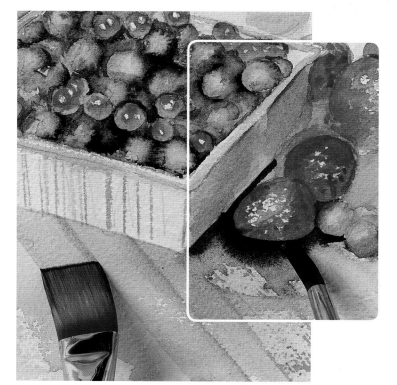

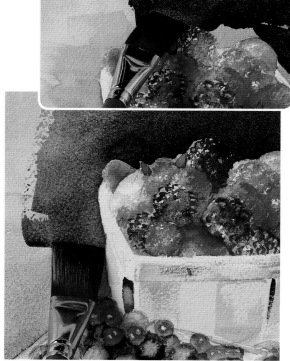

18 Go back to the green mix again to paint the table with the 1 in (25 mm) brush. Mix French ultramarine and burnt umber for shadows – for example, around the strawberries outside the basket. Use the No. 12 brush.

19 Paint the top right-hand corner with Windsor violet. Use the green mix on the 1 in (25 mm) brush for the rest of the background. Add more gamboge to this mix for the area to the left of the top basket.

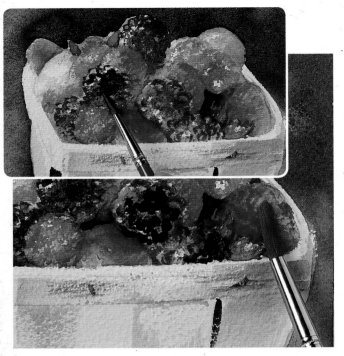

20 Add some cadmium red to the raspberries on the lower right-hand corner of the top basket using the No. 5 brush. Use the same color to soften the look of the blackberries.

21 Darken the background with the green mix on the 1 in (25 mm) brush. Define the blueberries on the lower left-hand side with the French ultramarine and alizarin crimson mix on the No. 5 brush. Paint the shadows with burnt umber.

"Ensure the baskets look strong enough to support the fruit inside."

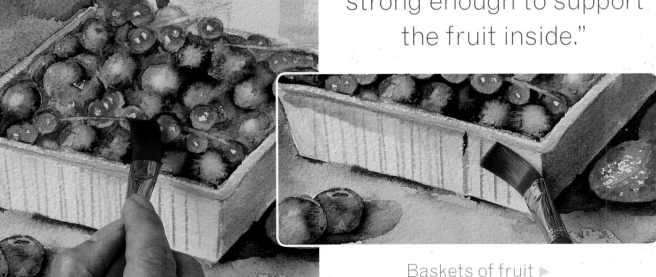

22 Lift out the stalks of the currants in the lower basket with the ½ in (12.5 mm) brush dipped in water. Use the green mix on the front of the lower basket to give the impression of depth.

Baskets of fruit ▶

The colors of the berries are clean and vibrant but vary in saturation, creating a natural and pleasing range of tones. Painting the berries wet in wet and as a group, rather than individually, helps to make them look soft and juicy.

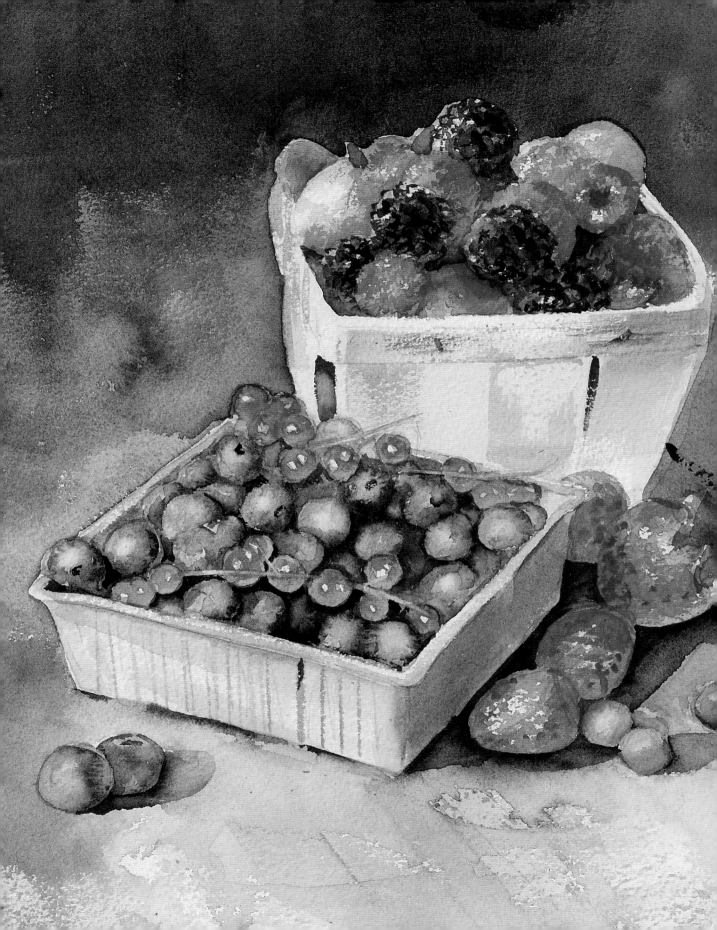

People and Animals

"Even as a sketch, a good portrait should capture the essence of the sitter."

People and animals

The main point to remember when painting people and animals is to approach them in the same way you would anything else. As soon as you start to think of them as complicated organic structures, you may worry about anatomy and then overcomplicate things. If you can see the subject simply as shapes, light and shade, and color – just as you do with less demanding subjects – the path forward will become much clearer.

SEEING IT SIMPLY

When it comes to living beings, the desire to depict each element accurately can lead to them being painted as separate, disconnected shapes. Try to see the bigger picture when looking at both people and animals, and you will see how all their parts are linked to one another.

This illustration shows how the figure in this work is treated merely as a shape along with all the others.

Once color has unified the shapes and tones, the figure is placed harmoniously in its environment.

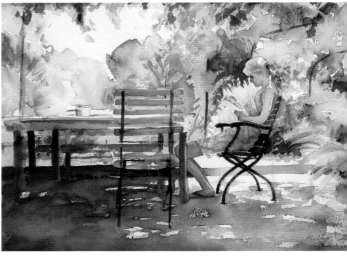

Girl reading The colors and tonal relationships here produce depth and light within the setting. The figure is handled in the same way as all the other elements in order to produce a painting with a figure rather than a portrait.

SETTING

When you paint people and animals, it is important to consider them in their setting. You do not want them to be isolated and cut out with a line around them, since this will give them no sense of form. The edges of living beings need to be softened and blended with their surroundings to create a feeling of volume. Edges that face the light tend to look hard, while those away from the light or in the shadows look soft. However, edges that you wish to emphasize should be harder, to draw attention to them.

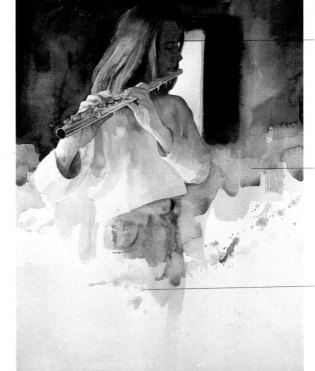

A strong tone produces a striking silhouette of the face.

Brush marks suggest the sound of the flute.

The lower half of the figure dissolves into the painting.

Girl playing flute This picture uses paint marks and brushwork to suggest the sound the flute is making. The face melts into the background, and attention is drawn to the silhouette. This makes the hands and flute the main focus of attention.

TEXTURE AND FOCUS

This portrait of a little girl places a great deal of attention on likeness. The success of the painting lies in the use of texture, specifically the smooth, soft face of the child and the dog's coarse hair. Softened edges help blend the figures into their surroundings, and the strong light on the right of the picture provides the areas of focus, which shift from the child's face to the dog and then to the child's hands.

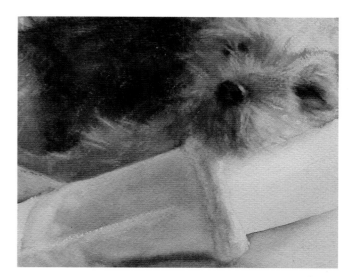

Soft edges blend into the background.

The use of sharp contrasts helps focus attention.

The wiry coat of the dog has been captured using dry brushwork on rough paper. This forms a contrast with the softened, blended edges of the girl's suede boots.

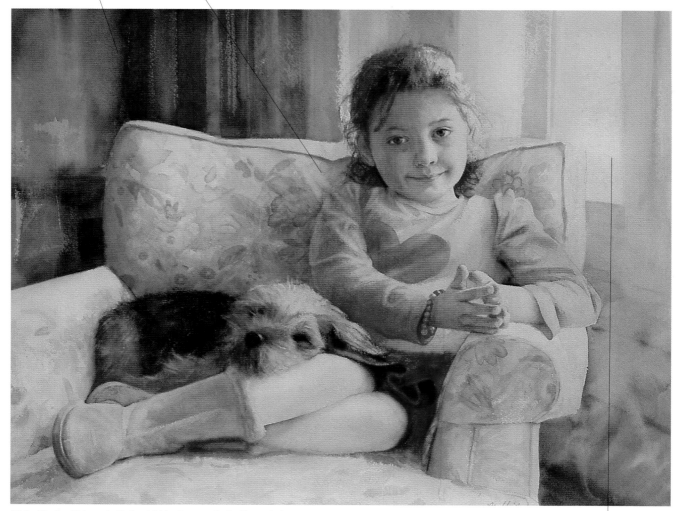

Girl with dog This portrait of a child is also a portrait of her pet dog. The two elements are blended together to create a single unit, which is then linked to the large armchair. Contrasting textures have given the girl and dog quite distinct characters.

The light creates big shapes that link everything together.

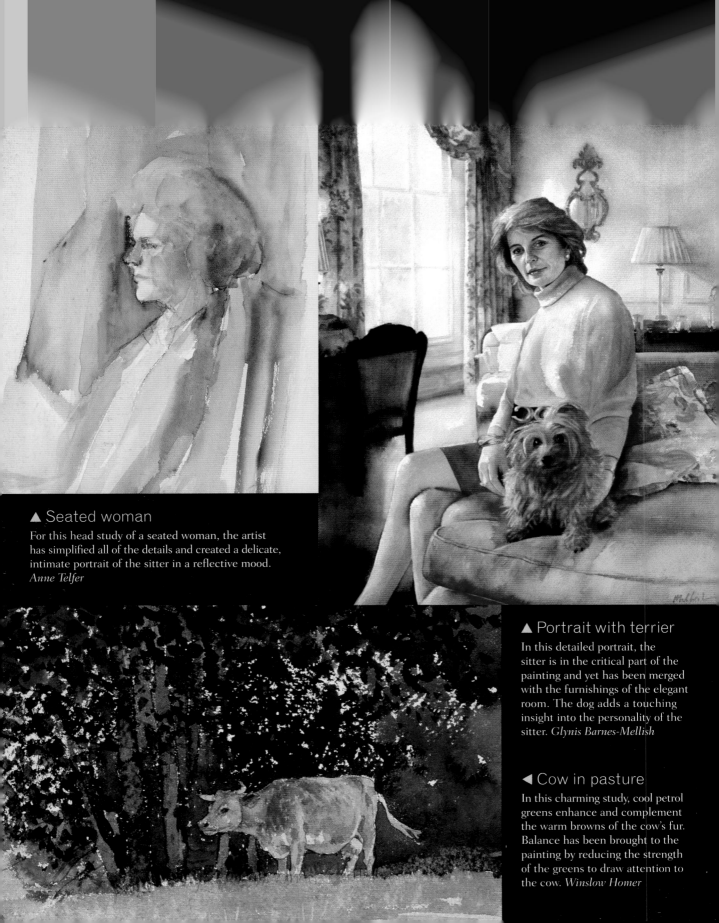

▲ Seated woman

For this head study of a seated woman, the artist
has simplified all of the details and created a delicate,
intimate portrait of the sitter in a reflective mood.
Anne Telfer

▲ Portrait with terrier

In this detailed portrait, the
sitter is in the critical part of the
painting and yet has been merged
with the furnishings of the elegant
room. The dog adds a touching
insight into the personality of the
sitter. *Glynis Barnes-Mellish*

◀ Cow in pasture

In this charming study, cool petrol
greens enhance and complement
the warm browns of the cow's fur.
Balance has been brought to the
painting by reducing the strength
of the greens to draw attention to
the cow. *Winslow Homer*

◄ Mrs. Gardner in white

In this unusual portrait, the sitter is almost entirely covered up and concealed. The artist has cleverly kept all the areas of pattern and color, as well as the strongest tonal contrasts, behind the subject's face so that we focus our attention there. *John Singer Sargent*

◄ Equestrian portrait

The focus in this double portrait is as much on the horse as it is on the rider, suggesting a close working relationship between the two subjects. *Glynis Barnes-Mellish*

▲ Trevor reading

The facial expression in this study has been painted with great enthusiasm and animation. By choosing an intense complementary color scheme of green and red, the artist has given the subject a strong personality. *Anne Telfer*

7 Ganges bathers

This setting features both horizontal and vertical direction. The strong horizontal lines of the steps and the reflections on the water create the impression of stillness. The vertical lift of the columns at the top of the painting gives a formal feeling to the scene, while the vertical color reflections at the bottom of the composition add a rational static influence to an otherwise chaotic setting. The diagonal lines of the women in the foreground link to the other figures, bringing movement back into the painting and maintaining interest all the way to the bottom of the picture.

EQUIPMENT
- Rough paper
- Brushes: No. 5, No. 9, ½ in (12.5 mm) and 1 in (25 mm) flat
- Yellow ocher, alizarin crimson, cerulean blue, French ultramarine, viridian, raw umber, burnt sienna, brilliant pink, Prussian blue, burnt umber, gamboge, sap green, cadmium yellow, cadmium red, cadmium orange
- Liquid-latex masking fluid

TECHNIQUES
- Wet on dry
- Splattering

1 Make your initial pencil sketch, and apply the masking fluid to any areas of the paper that are to remain white in the finished painting. Let the fluid dry before continuing.

BRUSH CARE
Wash your brush immediately after applying the liquid-latex masking fluid. Also, be sure to use an old nylon brush for this task, since a hair brush would be ruined.

2 Use the No. 12 brush to paint a mix of yellow ocher, alizarin crimson, and cerulean blue for the stone walls. Start at the top and work down, creating a warm mix on the paper. This color is good for peeling paint and brickwork. Use a mauve mix of alizarin crimson and cerulean blue for the column.

BUILDING THE IMAGE

 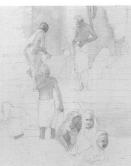 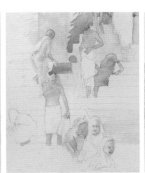 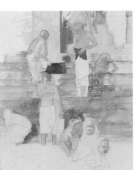 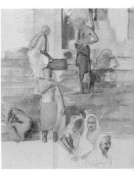

3 Add the mauve mix as a wash to the faces of the woman in the center and the man behind her. Paint a wash of alizarin crimson and yellow ocher, blending it to suggest the softness of skin tones. Use the No. 9 brush for the foreground faces.

4 Using the No. 12 brush, apply French ultramarine to the top right of the picture area, beyond the pillar. Create the base coat of the darkest shadows on the steps by adding viridian, again with the No. 12 brush.

5 Apply a viridian and yellow ocher mix to the right of the center column with the No. 9 brush. For the steps, use the stone mix from Step 2. Load your brush with water and splatter the steps to create a sun-bleached effect.

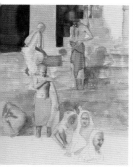
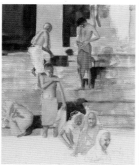
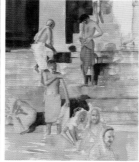
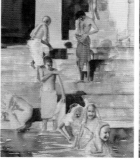
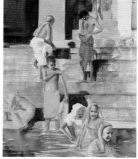

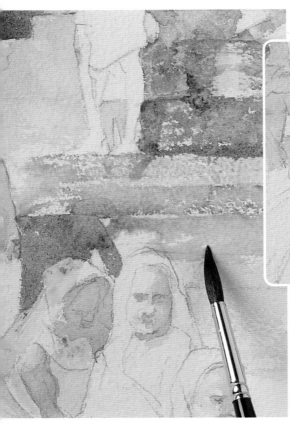

6 Paint the steps and stonework with the stone mix, using the No. 12 brush. Add a little cerulean blue to the area at the top of the steps on the left. Use a raw umber and French ultramarine mix over the green shadows. Give the steps a granulated look by adding the mauve mix.

7 Use light dabs of the mauve mix on the faces to give them a little bloom. Strengthen it with a touch more yellow for the legs, using darker and lighter tones to define musculature. Mix French ultramarine and burnt sienna to paint the marl-gray robe of the figure on the left.

8 Using the No. 5 brush, paint the robe of the central character on the steps with French ultramarine and alizarin crimson in turn. Use brilliant pink for the robe in the foreground.

9 Use the ½ in (12.5 mm) flat brush to paint the shaded area to the left of the column with a mix of alizarin crimson, Prussian blue, and burnt umber. To define the steps in that area, use pure alizarin crimson wet-in-wet. Add viridian to the right of the column with the same brush.

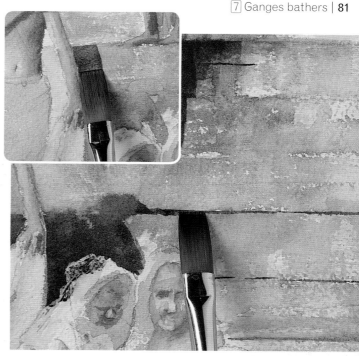

10 Apply yellow ocher to the right-hand steps with the 1 in (25 mm) brush. Add gamboge to the sari in the foreground with the No. 5 brush. Use the mauve mix for shadows on the bodies, and burnt sienna to give faces a golden look.

11 Add yellow ocher to the green shadows. Mix sap green and burnt sienna to create a gold-green for evening shadows. Add a shadow of burnt sienna to the right-hand column. Define the steps with the gold-green and the ¹/₂ in (12.5 mm) brush.

"The way in which forms such as bodies link the whole work is hugely important."

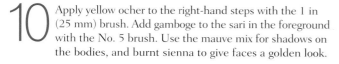

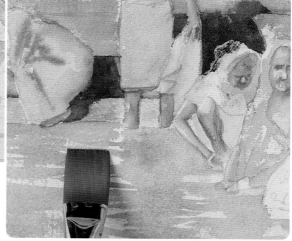

12 Paint the reflections of the pink towel with brilliant pink, and the golden sari with gamboge. Use a cerulean blue and viridian mix for the water. Mix viridian and cadmium yellow to make an acid green to paint below the gray figure. Use a mauve wash on the center column.

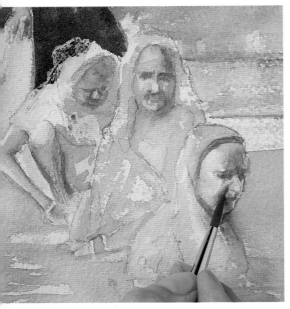

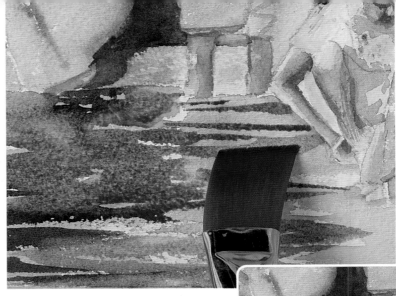

13 With the No. 5 brush, use the mauve mix for the front of the headdress of the woman in the bottom-right foreground, and cadmium red for the rest of it. Use a mix of yellow ocher, alizarin crimson, and cerulean blue for her dark skin tone.

14 Add the gold-green from Step 11 for shadows where the steps meet the water, using the wet tip of the 1 in (25 mm) brush to break it up. The water at the very bottom left should reflect the picture's top left, so use a mix of burnt umber, French ultramarine, and alizarin crimson. Add burnt sienna to the green at the bottom left to make it less bright.

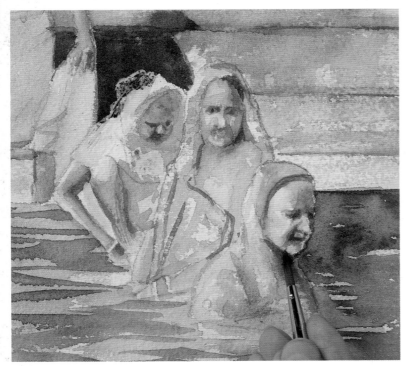

15 Paint the details of the gold sari with burnt sienna; use the marl-gray mix from Step 7 for the same woman's hair. Add the final shadows with browns and cadmium red. Using the No. 5 brush, add a cadmium orange separator between the foreground figures.

16 Strengthen any colors where needed. Remove the latex resist from all areas, revealing clean white paper.

Ganges bathers ▶

By constantly shifting from one diagonal element to another, a path of interest is carved through the horizontal line of the steps. This emphasizes the vertical elements of the composition and helps unite the figures in this heavily populated scene.

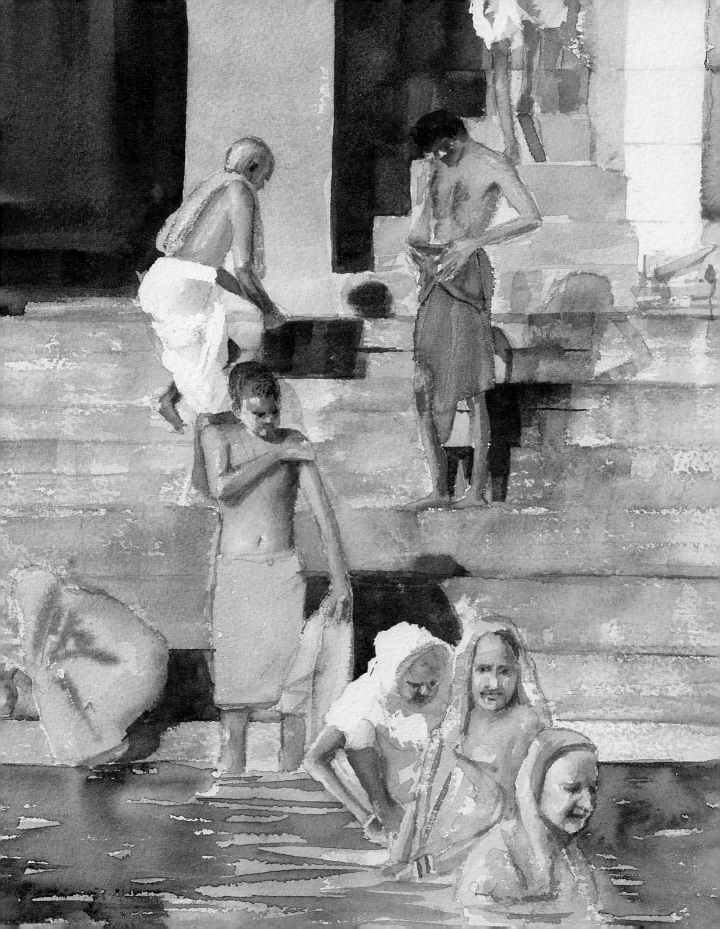

8 Nude

A painting of a familiar form, such as the human figure, can be greatly enhanced by an interesting composition. Although the nude is the main point of interest in this painting, it is portrayed in a setting rich in other elements that add interest in terms of both rhythm and mood. The strongly lit table and bowl in the foreground, for example, act as a barrier to the figure of the girl, yet draw the eye diagonally toward her, while the late-afternoon shadows, echoed in many of the dark areas of the painting, help link the various parts of the composition.

EQUIPMENT
- Cold-pressed paper
- Brushes: No. 5, No. 9, No. 12, ½ in (12.5 mm) and 1 in (25 mm) flat, squirrel, sable
- Alizarin crimson, yellow ocher, cadmium yellow, cadmium red, emerald green, cerulean blue, Windsor violet, lemon yellow, burnt umber, French ultramarine, cadmium orange, burnt sienna, sap green, Prussian blue

TECHNIQUES
- Painting skin tones
- Painting light

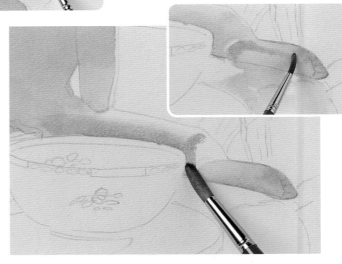

1 Apply a skin wash of alizarin crimson and yellow ocher. Use the 1 in (25 mm) brush for the face, back, arms, and foot. Push away the color on the face with a soft, damp brush. Paint the nose with the tip of the No. 12 brush.

2 Paint the leg and ankle with pure alizarin crimson. Bring the foot forward by adding an orange mix of cadmium yellow and cadmium red for the heel, using the No. 5 brush. Add the same mix to the side of the girl's face.

BUILDING THE IMAGE

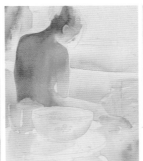
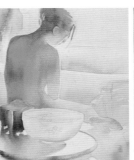
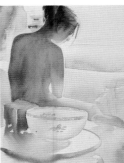

3 Paint the drapes with a cadmium yellow, cadmium red, and emerald green mix, using the No. 12 brush. Use cerulean blue on the 1 in (25 mm) brush for the top half of the scene.

4 Paint the sofa to the right of the girl's arm with yellow ocher, using the 1 in (25 mm) brush. Add Windsor violet above this to define the top of the sofa.

5 Use the three-color mix from Step 3 and a 1 in (25 mm) brush to paint the box. Leave untouched areas around the edges and add alizarin crimson to the right-hand side of the box.

6 Use the squirrel brush to paint the right-hand side of the bowl with Windsor violet; use alizarin crimson on the left. Add lemon yellow to the left of the Windsor violet to give texture to the porcelain. Blend it in.

7 Apply a second wash on the skin. Paint the girl's body with a mix of burnt umber, alizarin crimson, and a little cerulean blue, using the 1 in (25 mm) brush. Use the same mix – though with less blue – around the ear and on the hair.

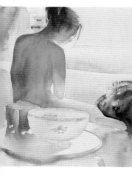

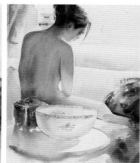

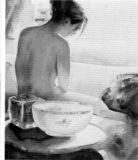

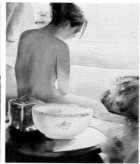

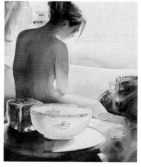

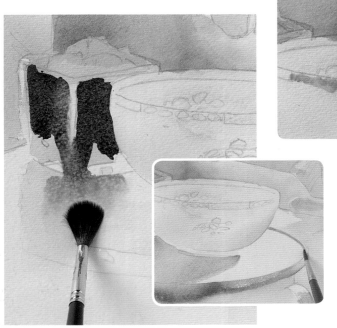

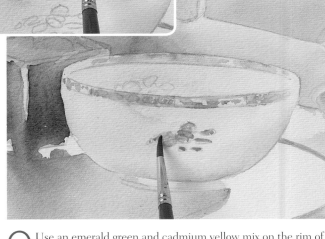

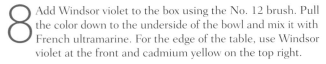

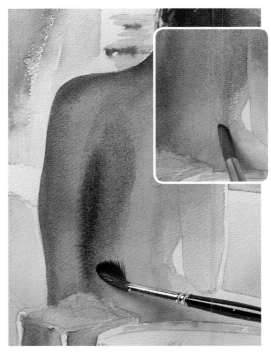

8 Add Windsor violet to the box using the No. 12 brush. Pull the color down to the underside of the bowl and mix it with French ultramarine. For the edge of the table, use Windsor violet at the front and cadmium yellow on the top right.

9 Use an emerald green and cadmium yellow mix on the rim of the bowl. The inside rim is a mix of emerald green, cadmium yellow, and cerulean blue. Paint the detail on the bowl with cadmium orange and cerulean blue, using the No. 5 brush.

10 Use a gold mix of cadmium yellow and emerald green for the area to the left of the neck. Paint the hair with pure burnt umber, then add some Windsor violet for extra warmth. Pull the lilac down into the orange on the edge of the girl's face with the No. 9 brush. Use the squirrel brush to blend the colors so that there are no hard edges.

11 Paint the girl's spine with Windsor violet, and her back with burnt umber. Using the No. 12 brush, lighten this color with burnt sienna (acting as an orange) over the shoulders and down the arm. Blend it in. Define the top of the box with burnt sienna.

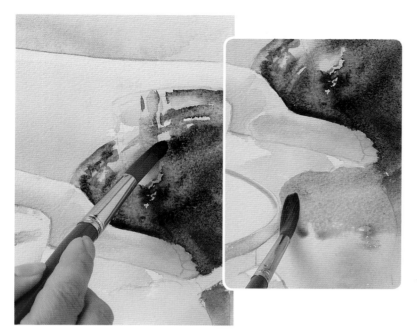

12 Paint the tops of the cushions with French ultramarine using the No. 12 brush, and the bottom halves with a burnt sienna and sap green mix. For the throw below the girl's foot, use a mix of alizarin crimson and Windsor violet. Leave a white highlight below the foot.

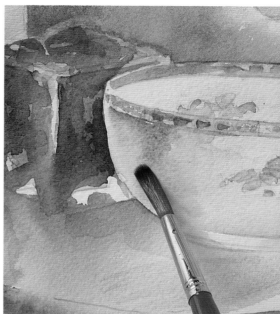

13 Dab the green sections of the bowl's front rim decoration with a mix of sap green and French ultramarine, using the No. 5 brush. Use burnt sienna for the orange sections. Some Windsor violet on the left side of bowl, away from the edge, adds sheen.

CONVINCING SKIN TONES

Yellow ocher is a good color for using in skin tones. Because it is softer than raw sienna and is a sedimentary pigment, it will granulate and create nice effects and color when combined with alizarin crimson and cerulean blue. This softness of color is essential to produce lifelike skin tones.

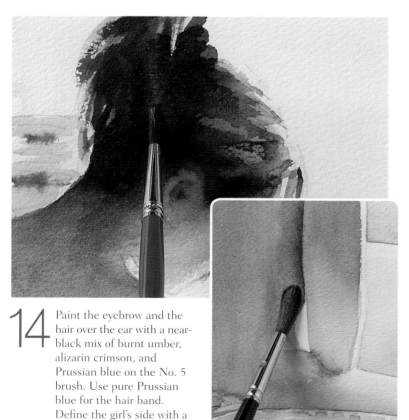

14 Paint the eyebrow and the hair over the ear with a near-black mix of burnt umber, alizarin crimson, and Prussian blue on the No. 5 brush. Use pure Prussian blue for the hair band. Define the girl's side with a mix of Windsor violet and the near-black. Blend it in.

15 Add some cadmium orange to the sole of the girl's foot. While this is still wet, apply some Windsor violet on the toes; extend this color to the cushions with the No. 5 brush. A dab of cadmium orange on the cheek and ear will give depth to the face.

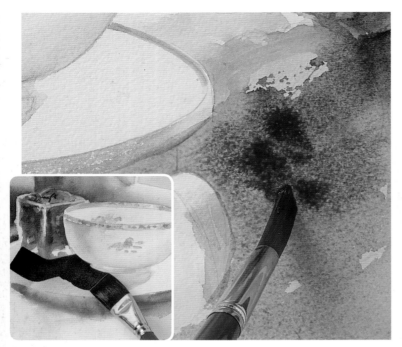

16 Paint the throw with a mix of burnt umber and alizarin crimson, using the No. 12 brush. For texture, dab in a darker mix (with more crimson). With the 1 in (25 mm) brush, paint the foreground area of the table with a mix of Windsor violet and the near-black.

17 Use the same mix to paint under the table. Blend it with a clean brush to define the edges. Add more blue and alizarin crimson to the near-black mix to give more depth to this area.

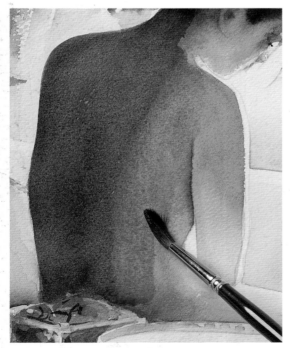

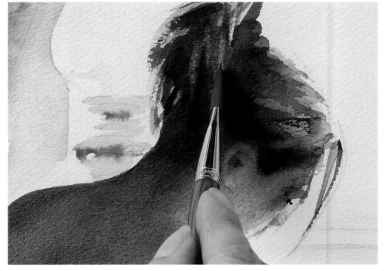

18 Mix burnt sienna and Windsor violet, and apply this color as a third wash over the girl's body, from the neck down the back. Use a soft sable brush for this. Dab a little bit of this mix on the edge of her left shoulder, too.

19 Lift out highlights in the girl's hair with the ½ in (12.5 mm) brush. Add a little burnt umber and Windsor violet mix above the top rim of the bowl. Dab some French ultramarine on the cushions with the sable brush to add detail.

Nude ▶

The strong white light in this painting focuses your eye on the girl's face and traces patterns throughout the whole composition. Using rivers of light as a counterpoint to the shaded areas has created a striking, dynamic image within a calm, harmonious setting.

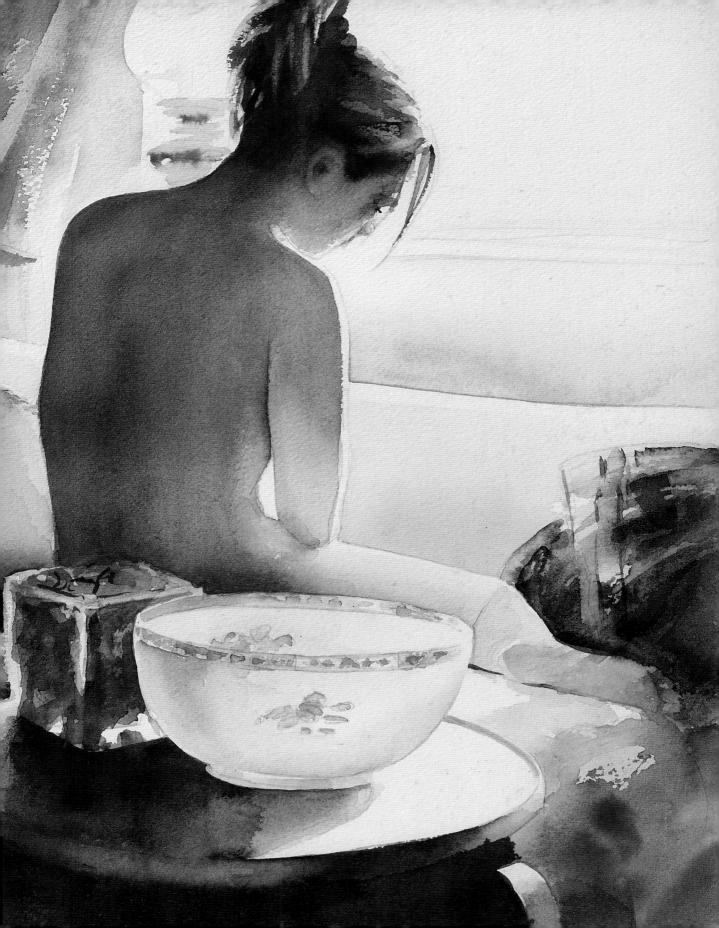

9 Girl with rabbit

The main concern in this image is the softness of the child's skin and the animal's fur. Wet in wet is used to render the rabbit's coat, by delicately and lightly dragging the brush over the rough surface of the paper and working into a damp wash. Because of the sunlight and shadows, this image has a varied pattern. The alternation of light on dark and dark on light switches the emphasis from one area to another, creating a rhythmic composition. By using negative and positive shapes to define the areas of interest, all the important elements of the painting are clearly stated.

EQUIPMENT
- Rough paper
- Brushes: No. 5, No. 12, ½ in (12.5 mm) flat, squirrel
- Alizarin crimson, yellow ocher, cerulean blue, cadmium red, cadmium yellow, burnt umber, burnt sienna, French ultramarine, Prussian blue

TECHNIQUES
- Softening edges
- Positive and negative shapes

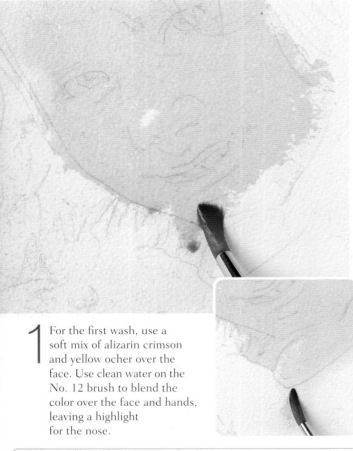

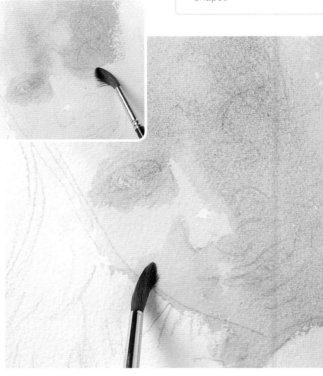

1 For the first wash, use a soft mix of alizarin crimson and yellow ocher over the face. Use clean water on the No. 12 brush to blend the color over the face and hands, leaving a highlight for the nose.

2 Let the wash dry, then add cerulean blue to the mix and paint a second wash. Apply it over the eye sockets and the right-hand side of the face. Take the time to achieve the right degree of softness to the skin.

BUILDING THE IMAGE

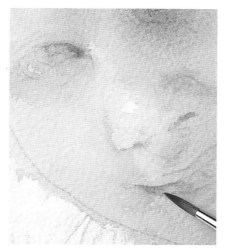

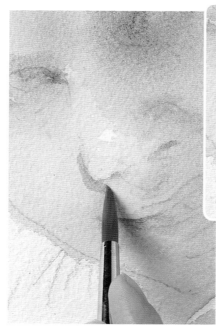

3 Apply cadmium red to the corners of the eyes and down the center of the face to create warmth. Add the same color to the girl's nostrils, mouth, lips, and fingertips.

4 Use pure yellow ocher on the tip of the squirrel brush to paint the fleshy areas around the girl's eye, at the edge of her nose, and underneath her mouth.

5 Add alizarin crimson with a wet brush to both cheeks – up to the yellow on the left, and to the long strand of hair on the right. Because alizarin crimson is a cool color, use it at the sides of the face, keeping the focus in the middle.

6 Use a little cerulean blue below the mouth, going into the yellow, and also in the eyes. For the right-hand eye, which is in shadow, mix cerulean blue and alizarin crimson. This opaque blue will give a hint of softness. Allow the paint to dry.

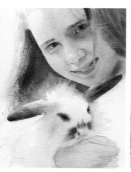

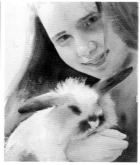

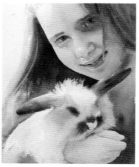

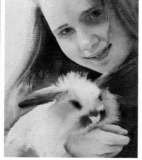

7 For the hair on the left of the painting, apply pure yellow ocher with the 1/2 in (12.5 mm) flat brush, using the paper's rough surface to break up the marks. Take care not to touch the rabbit.

8 Use a mix of cadmium yellow and cadmium red around the right of the face. For the hair at the top left, add cerulean blue, which is a little green in color. This stops the hair from looking too brassy. Apply pure yellow ocher to paint the hair falling across the girl's face.

9 Mix a mauve from cerulean blue and alizarin crimson for the hand. Use this to define bone structure, blending and softening it with the No. 5 brush. Apply the mauve to the base of the hand, as well as to the thumbnail.

"Portrait work requires a softer, warmer palette than that used for landscapes or still lifes."

10 The next step is to add some key mid-dark colors to create structure. Use burnt umber for the area around the eyes and nose. Blend it with water. You will use more of this color on a child's face than on that of an older person.

11 Apply pure alizarin crimson to the lips, and blend it with water to vary the tone. Remember to leave some highlights too, as you did on the nose in Step 1.

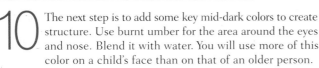

NEGATIVE PAINTING

Negative shapes are the background spaces between things. They enable us to see the positive shapes, as well as helping to create them by carving out the object's outer edges. While applying the paint to the paper, you must remember to keep a very firm eye on the untouched paper and take note of what negative shape is being created.

12 Blend a burnt umber and cerulean blue mix into the eyebrows. Use alizarin crimson in the corners of the eyes. Mix Prussian blue with alizarin crimson for the eyes; add burnt umber to make a soft-black mix for the pupils.

13 Paint the line between the hair and the left-hand cheek with a mix of burnt umber and alizarin crimson. Blend it into the hair. Use this for the shadow on the right-hand cheek too. Add cerulean blue to the hair on the right.

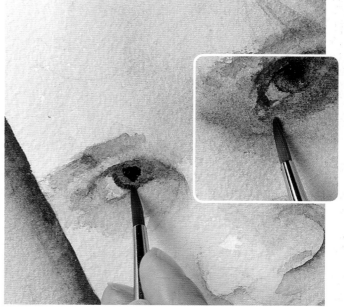

14 Blend the cerulean blue that was added to the hair with the ½ in (12.5 mm) brush to give texture to the hair, and add some yellow ocher. Dab at the picture with clean tissue to break up the marks.

15 Retouch the pupils with the soft-black mix, and define the eyes with the Prussian blue and alizarin crimson mix on the No. 5 brush. Use the burnt umber and cerulean blue mix for the eyelids and areas above and below the eyes.

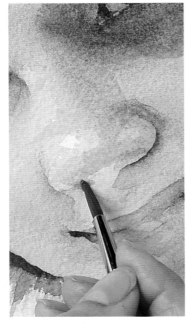

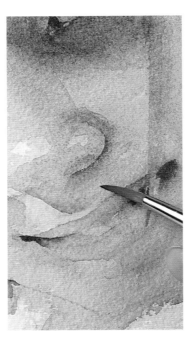

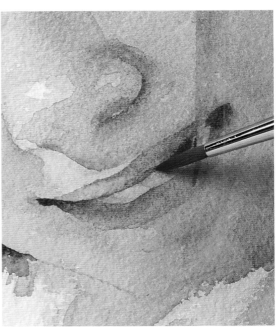

16 Add a little cadmium red to the nostrils, using a very light touch, with the No. 5 brush.

17 Add shadow beneath the nose with a mix of cerulean blue, yellow ocher, and alizarin crimson.

18 Use the soft-black mix for the hair on the left. Apply alizarin crimson to the lips with the No. 5 brush. Go back to the soft-black mix to strengthen the eyes and define the eyebrows.

19 Use yellow ocher to strengthen the stray hair, then emphasize the bottom lip with pure alizarin crimson. Apply a cerulean blue and yellow ocher mix to the dark areas beside the girl's mouth and nose.

20 Paint the rabbit's ears with the soft-black mix, and use a mix of cerulean blue and alizarin crimson for the shadows on its fur. Add yellow ocher to it on the paper, and add the details with the soft black. Mix burnt umber, Prussian blue, and alizarin crimson for the muted gray of the rabbit's fur.

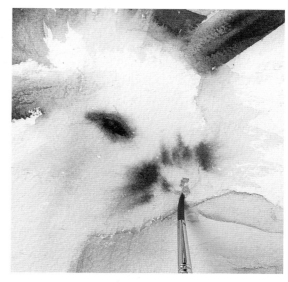

21 Paint the lower part of the hair on the left with burnt umber. Work down toward the top of the rabbit's head, since this negative painting will further define its shape. With a damp, clean brush, drag color into the fur on top of the rabbit's head to soften it.

22 Apply a touch of alizarin crimson with the No. 5 brush to the tip of the rabbit's nose. Paint its eye with the soft black. While the rabbit dries, you can work on the sweatshirt.

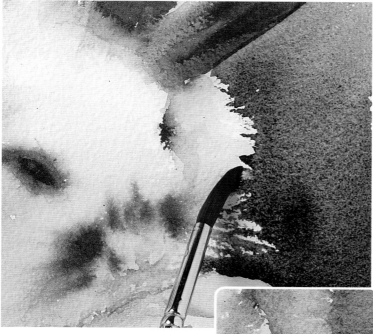

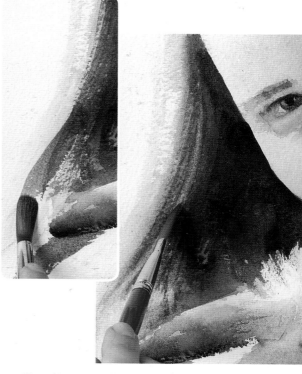

23 Make the gray marl for the sweatshirt with a mix of burnt sienna and French ultramarine. Apply it with the No. 12 brush. Strengthen all the colors of the rabbit. Making sure the 1/2 in (12.5 mm) brush is clean and not too wet, use it to lift out the rabbit's whiskers.

24 Add shadows to the hair at the left of the face with the soft black, using the No. 12 brush. Apply burnt sienna to the left of the hair and below the rabbit's ear. Blend it in. Use yellow ocher on the 1/2 in (12.5 mm) flat brush for the lighter hair color. Lift out highlights with a wet brush.

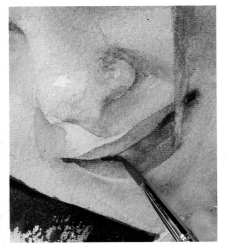

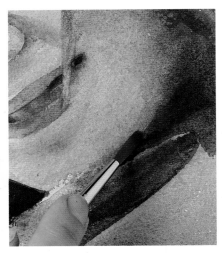

25 Add a little pure alizarin crimson to the right of the nose. Use burnt sienna to strengthen the eye, then paint soft black in the corners of the mouth.

26 Use the soft black around the chin too. Add some of the alizarin crimson and cerulean blue mix underneath the chin area and blend it in.

27 Return to the girl's sweatshirt, adding more of the original gray-marl mix to darken it slightly.

28 To paint the shadow on the girl's hand, use the mix of alizarin crimson, yellow ocher, and cerulean blue, as in Step 2.

29 Gradate the ears of the rabbit to give them some definition. Work from black to brown, using the drybrush technique.

30 Finally, add a mix of cerulean blue and yellow ocher to the hair at the top of the picture, and further define the shape of the eyes using burnt sienna.

Girl with rabbit ▶

Because it is such a close-up view, this picture incorporates a very simple description without unnecessary details. This means that the areas of interest have room to be expressive, while remaining loose and freely handled.

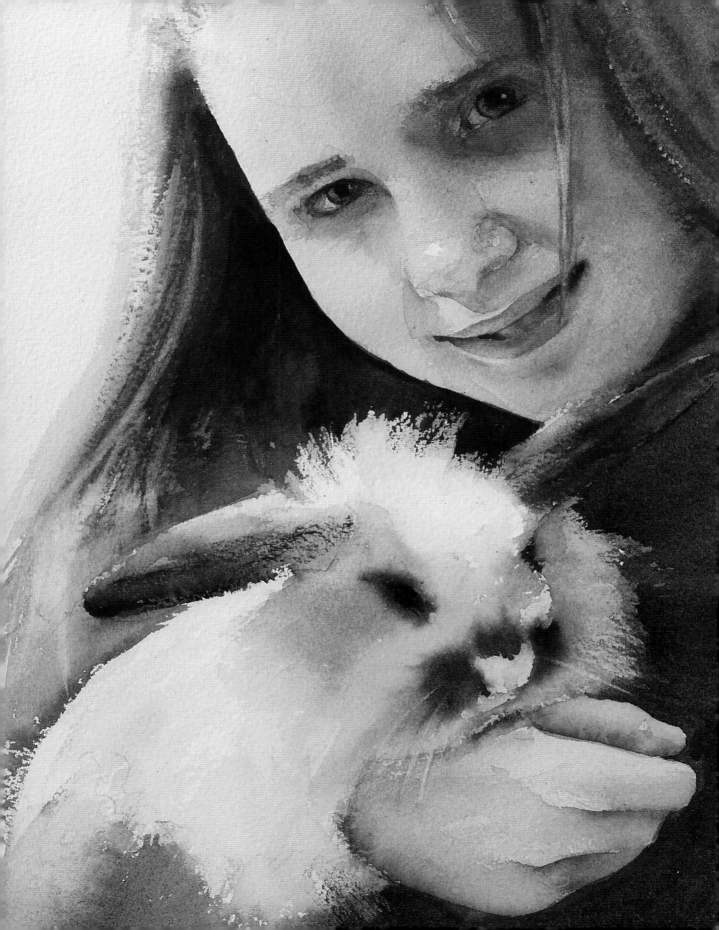

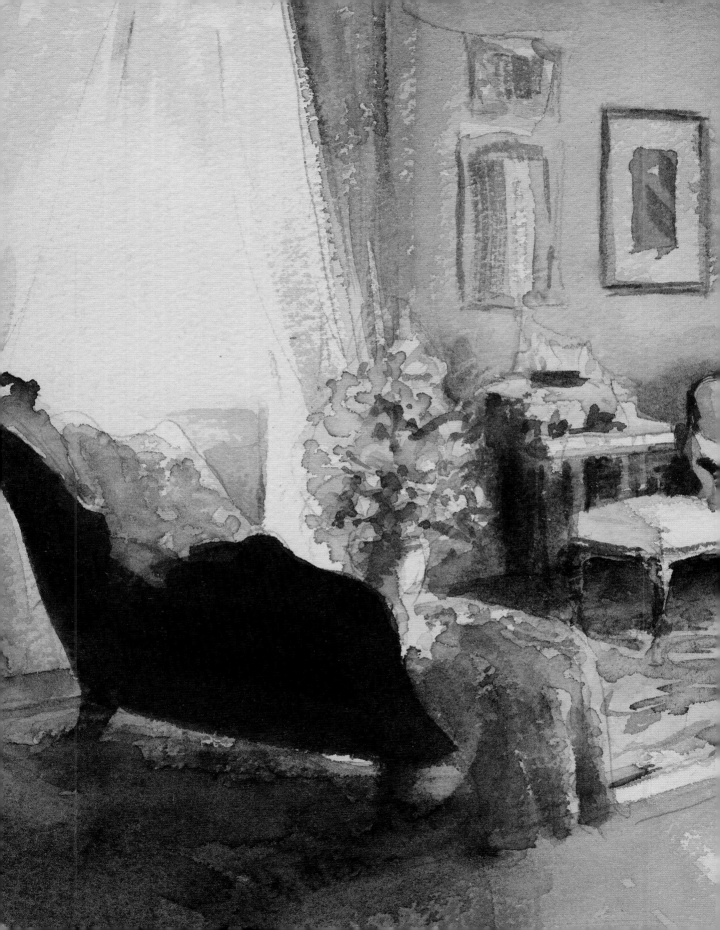

Interiors

"It is vital for a painting of an interior to evoke a mood."

Interiors

This subject leads perhaps to the most beautiful paintings of all in terms of arrangement. Traditionally, interiors have been backdrops for other subjects, notably portraits, and have therefore been rather neglected as a subject matter in their own right. They are a blend of still-life and landscape painting, combining the sense of scale of the latter with the compositional elements of the former.

HARMONY AND SIMPLICITY

In a small room, light and color are reflected all around, creating a harmonious overall scheme. This means that small interiors are less varied chromatically than large ones. An interior that is filled with strong colors provides the perfect opportunity to simplify the details of the scene, allowing shape and color to dominate.

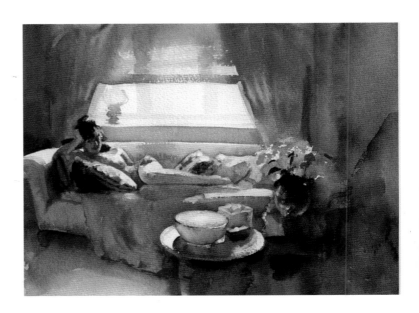

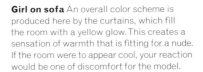

Girl on sofa An overall color scheme is produced here by the curtains, which fill the room with a yellow glow. This creates a sensation of warmth that is fitting for a nude. If the room were to appear cool, your reaction would be one of discomfort for the model.

COLOR INTEREST

You can create interest in a seemingly empty picture through use of color. This will divert the eye away from shapes that may otherwise look dull. In a painting that has an overall bias towards a particular color, you can use color dominance to provide unity. Having a major color theme in a painting will bring a sense of harmony.

Farmhouse dining room The warm colors used in this painting are calmed down through the addition of blues and purples. These cooler colors help to convey a sense of stillness.

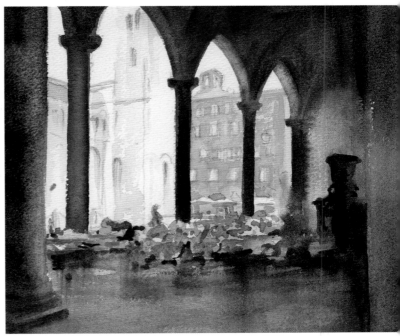

Flower market, Lucca This painting has been created with colors intended to provoke an emotional response. The muted cool colors contrast strongly with the bright ones to build visual excitement.

MOOD

At first glance, this painting seems like a simple interior of an almost empty room, but there is a real sense of atmosphere. This is created through tone – from almost black beneath the window, to bright white above the chair – as well as color: the hints of orange in the wall are complemented by the blue in the stone floor and pale bricks.

Placing the area of focus on the workman's hammer adds a human element to the painting. Suddenly the room seems more interesting.

Strong, dark colors draw attention from the middle of the room.

Faint shapes and colors outside imply a greater sense of space.

The brilliant turquoise green complements the reds in the walls.

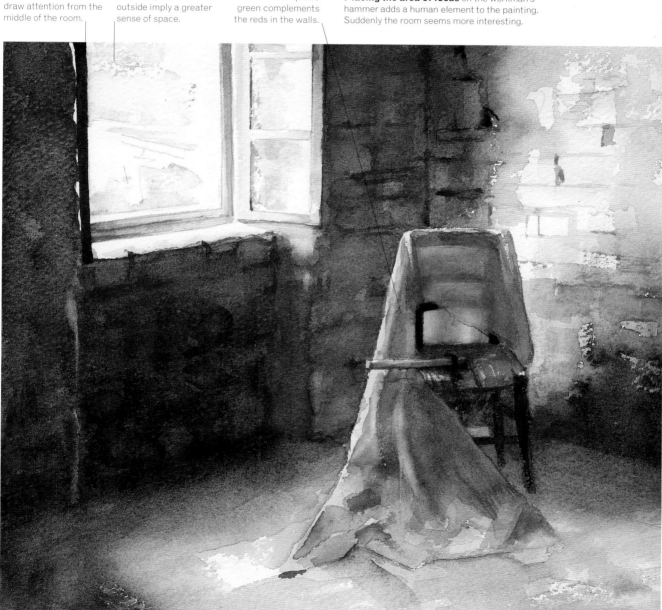

Chair with hammer To produce a vibrant color in this painting's main area, the turquoise green of the tarpaulin has been complemented with warm red-browns. This strong color contrast makes the turquoise even brighter and creates vibrancy in a picture that would otherwise seem quite empty. Although no person appears in the picture, the hammer on the chair evokes the feeling of an unseen presence.

Gallery

The flexibility of watercolors makes them just as good for interiors as they are for portraits, capturing the personality and beauty of any room.

Work shed ▶

This painting has used color for aerial perspective, as well as a more obvious linear perspective, to create the vast scale of the space. This effect gives the piece a haunting, empty quality. *Glynis Barnes-Mellish*

▼ Hallway reflections

By limiting the palette to a complementary arrangement of blue and orange, the artist has made a pleasant relationship of objects and produced a charming study of a very simple scene. *Sara Ward*

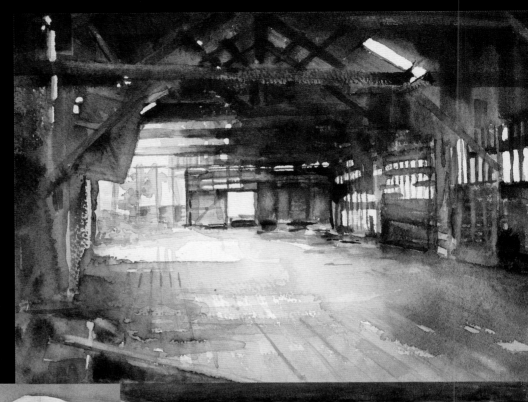

▲ Kitchen interior

This painting plays with the idea of looking into a room to lead us through one interior to another. Our visual pathway is controlled with areas of interest before finally arriving at the small figure at the window. *Johannes Hendrik Weissenbruch*

3 Paint the apples with cadmium red, then with an emerald green, cerulean blue, and Indian yellow mix. Use a mix of Indian yellow and alizarin crimson on the eggs. Paint the rolling pin with Indian yellow and cadmium red.

4 Paint the right side of the table with French ultramarine on the No. 12 brush. Use the eggshell mix from Step 3 for the window's midhorizontal, and an Indian yellow and sap green mix and the No. 5 brush for the rest of the frame.

"Keep the design simple and avoid too much detail."

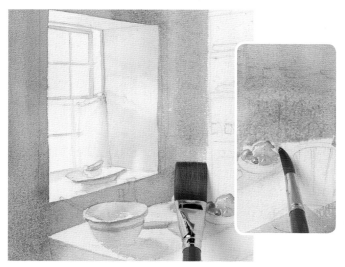

5 Apply a neutral-brown wash of Indian yellow and Windsor violet over the wall and cabinet, using the 1 in (25 mm) brush. Use pure Windsor violet at the very top, then blend it in, allowing the color to grow lighter as you come down.

6 Paint the area under the windowsill with pure Indian yellow using the 1 in (25 mm) brush. Apply the neutral-brown mix on either side of the window, and a mix of alizarin crimson and French ultramarine over the cupboard doors.

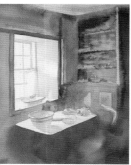
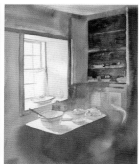
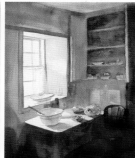
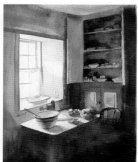
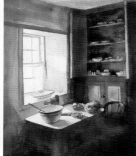

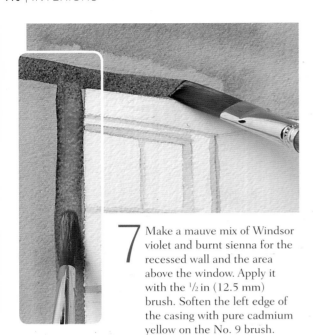

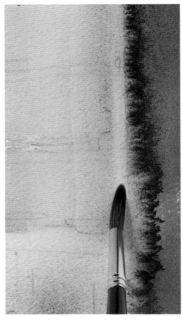

7 Make a mauve mix of Windsor violet and burnt sienna for the recessed wall and the area above the window. Apply it with the 1/2 in (12.5 mm) brush. Soften the left edge of the casing with pure cadmium yellow on the No. 9 brush.

8 Dip the squirrel brush into clean water, and use it to soften and lift out some color from the right-hand side of the dresser. This will help prevent an irregular edge.

9 Paint the front and left-hand side of the table with the mauve mix, using the 1 in (25 mm) brush. Use the same mix below the table, toward the bottom of the picture.

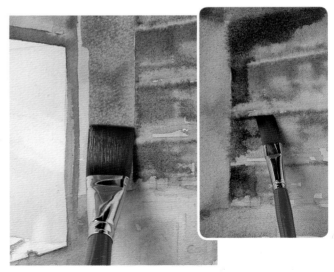

10 Paint the shelves with a cadmium red, cadmium yellow, and sap green mix, using the 1/2 in 12.5 mm () brush. Dab a little alizarin crimson too. Use the mauve mix on the 1 in (25 mm) brush for the shadows below the shelves.

11 Mix Indian yellow, burnt sienna, and Windsor violet for use on the left dresser door with the 1 in (25 mm) brush. Dab some French ultramarine on the left-hand side of the shelves with the 1/2 in (12.5 mm) brush to create depth.

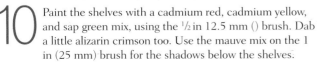

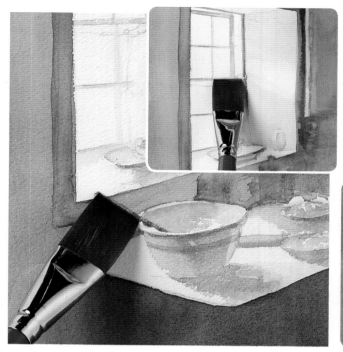

12 Paint the spoon in the bowl with the mauve mix on the 1 in (25 mm) brush. Use a mix of Windsor violet and French ultramarine on the bottom right-hand corner of the window, and Indian yellow for the window frame.

13 Darken the shelves with a burnt sienna and French ultramarine mix on the ½ in (12.5 mm) brush. Be careful not to lift any color beneath. As you move toward the light source, add more Indian yellow to the mix.

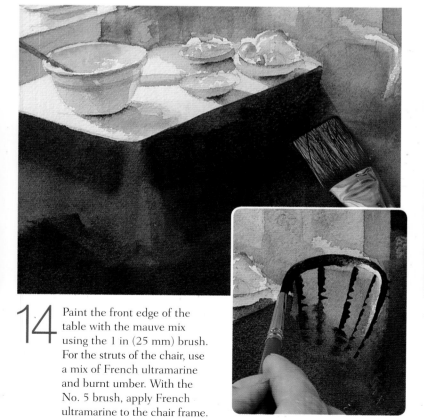

14 Paint the front edge of the table with the mauve mix using the 1 in (25 mm) brush. For the struts of the chair, use a mix of French ultramarine and burnt umber. With the No. 5 brush, apply French ultramarine to the chair frame.

15 Use pure Windsor violet on the No. 5 brush to paint the shadows in front of the bowls. Break the line of the windowsill with pure burnt umber. The dark jar behind the main bowl also provides a break between the two yellows.

16 Drybrush the area to the right and to the bottom of the table with the neutral-brown mix from Step 5 using the 1 in (25 mm) brush. Use the same mix to darken the dresser doors.

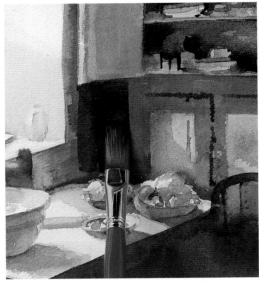

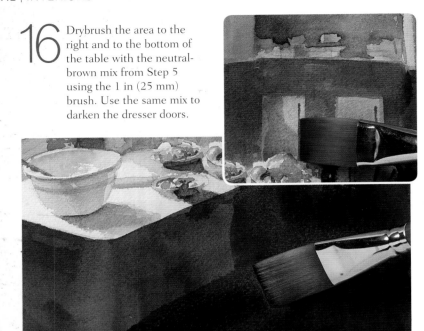

17 Paint around the bowl and other objects on the shelves with a dark mix of burnt umber, alizarin crimson, and French ultramarine on the ½ in (12.5 mm) brush. Use the same dark mix and brush for the shaded areas to the left of the cupboard.

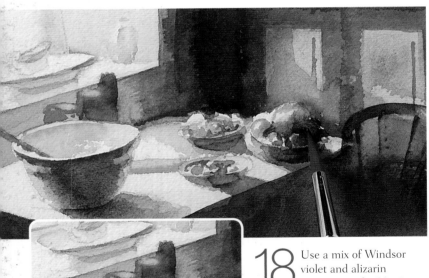

18 Use a mix of Windsor violet and alizarin crimson on the No. 5 brush for the apples on the right. Strengthen the stripes on the main bowl with pure alizarin crimson. Create the shadow of the rolling pin behind the main bowl with Windsor violet, then apply a burnt umber wash over the rolling pin itself.

19 Use a clean wet brush to lift out the objects on the shelves. Darken the top of the dresser, the ceiling, and the area to the left of the dresser with the neutral-brown mix of Indian yellow and Windsor violet, using the 1 in (25 mm) brush.

Cottage kitchen ▶

This composition focuses on the objects on the table. Interest in this relatively small area of the overall painting is highlighted by a careful use of tone and by using the light from the window to unify these everyday items.

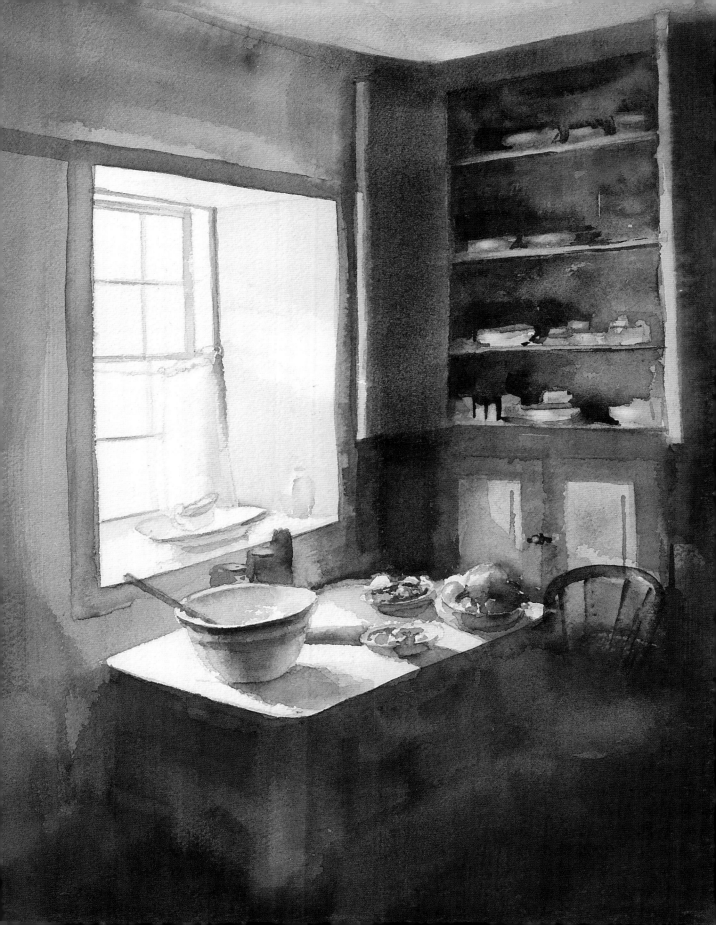

12 Diner

This painting is separated into two equal halves by the blue counter. In order to create visual interest, it is necessary to introduce elements that break up that symmetry. It is hard to alter the relationships between shapes when painting an interior, but you can subtly alter color and tone to create variety within the shapes themselves. Here, the green hues used in the bottom half of the painting are repeated in smaller areas of the top half, helping to break up what would otherwise be a rigidly symmetrical composition and to create a sense of rhythm.

EQUIPMENT
- Cold-pressed paper
- Brushes: No. 5, No. 9, No. 12, ½ in (12.5 mm) and 1 in (25 mm) flat, squirrel
- Lemon yellow, cerulean blue, French ultramarine, burnt umber, Prussian blue, manganese blue, emerald green, cadmium yellow, cadmium orange, alizarin crimson, cadmium red, cobalt blue, yellow ocher, burnt sienna
- Masking tape

TECHNIQUES
- Dry on dry to control edges

1 Put some masking tape on your sketch to preserve the large counter area, which will be painted later. Using broad horizontal strokes, apply a lemon yellow wash over everything using the 1 in (25 mm) brush. The yellow works as a unifying element for all the colors that will be used later.

2 Brush water on the damp wash to add light in certain places, such as on the wall behind the counter. Lift out some paint from the milkshake maker with the damp No. 12 brush.

BUILDING THE IMAGE

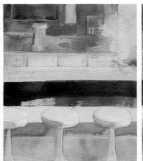
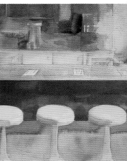

3 Add cerulean blue with the 1 in (25 mm) brush to make a green for the items on the back shelf. Use French ultramarine over the drink dispenser and for the darker areas of the wall on the right.

4 Paint around the stools with a mix of cerulean blue and French ultramarine using the 1 in (25 mm) brush. Use the same mix on the No. 5 brush for the edges of the stools. The stools will be painted red later, and this layer will help you achieve a range of tonal variations.

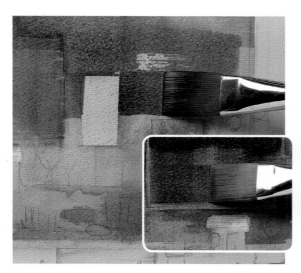

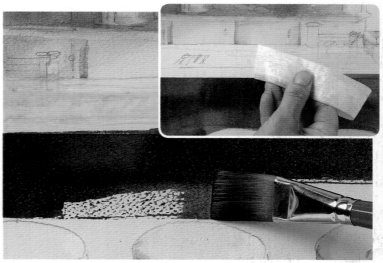

5 Apply burnt umber at the top of the picture with the 1 in (25 mm) brush. Use a French ultramarine and burnt umber mix to darken the blackboard. Use the one-stroke technique to make straight lines.

6 Make a near-black mix of burnt umber and Prussian blue, and use it on the 1 in (25 mm) brush to paint the area below the counter. The burnt umber adds warmth. Use this mix around the stools too. Once the paint is dry, remove the tape, which has helped create straight lines.

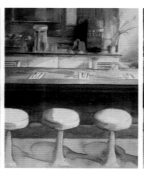

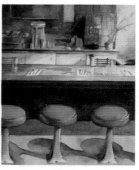

"The best watercolors are those that do not appear to be heavily overworked."

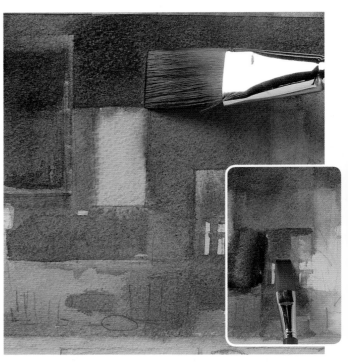

7 Paint the counter with manganese blue, using the ½ in (12.5 mm) flat brush. Apply the color in broad horizontal strokes, making sure you work around the white napkin areas. Leave the painting to dry.

8 Paint the top right-hand corner of the wall with burnt umber. Blend it in. Use the near-black mix on the 1 in (25 mm) brush for the top of the picture. Add French ultramarine to and around the milkshake maker and the drink dispenser.

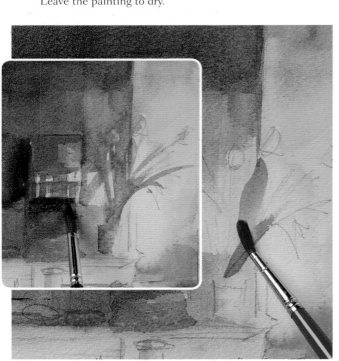

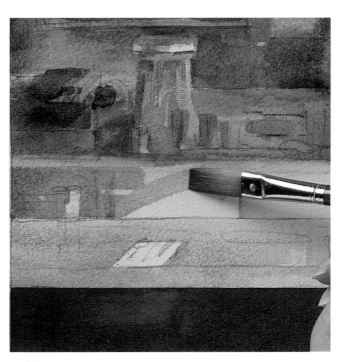

9 Paint the plant on the right of the shelf with emerald green, and the flowers with cadmium yellow. Use cadmium orange on the No. 5 brush to the left of the flowers, and alizarin crimson for the vase and the area to the left of the shelf.

10 Make a hot brown by mixing cadmium orange and a little burnt umber. Add some cerulean blue to the mix for the shadows on the top left of the cabinet doors, using the ½ in (12.5 mm) brush.

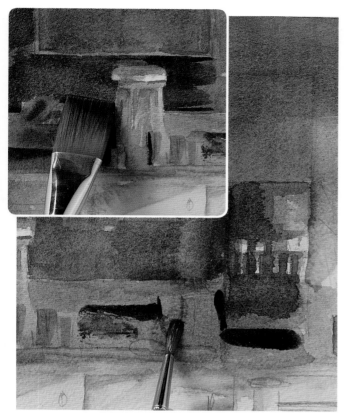

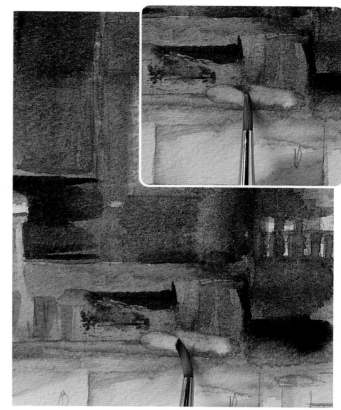

11 Paint the shadows to the left of the milkshake maker and under the drink dispenser with the near-black mix, using the No. 5 brush. Use the same mix with the 1 in (25 mm) brush as a dark neutral base before using brighter colors.

12 Lift out some of the base before adding more color; this will brighten up the subsequent layer. Add cadmium yellow on the apples, followed by alizarin crimson. Paint the top of the drink dispenser with cadmium red.

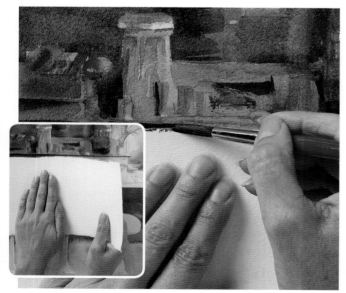

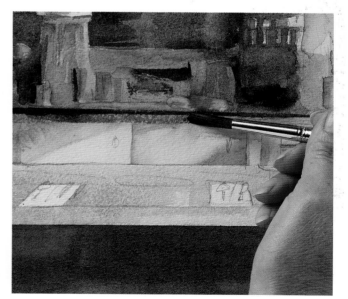

13 Tear a piece of watercolor paper with a ruler in order to achieve a straight edge. Use this as a guide to paint the edges of the shelf. Paint these with the near-black mix using the No. 9 brush.

14 Use a more diluted version of the near-black mix of burnt umber and Prussian blue to soften the area immediately below the edge of the shelf. Use this as a shadow color.

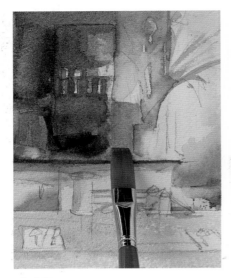

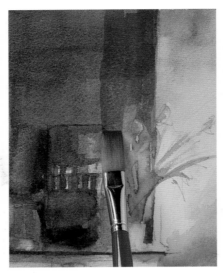

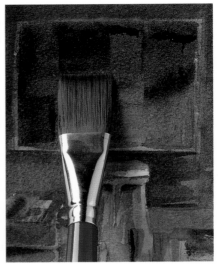

15 Paint the area to the right of the drink dispenser with cerulean blue using the ½ in (12.5 mm) flat brush. Use the same color on the central section of the back shelf, between the milkshake maker and the drink dispenser.

16 Add a little cadmium orange to the near-black mix to paint the late-afternoon shadows. Apply this to the area on the right of the blackboard and to the right of the drink dispenser with broad vertical strokes.

17 Strengthen the blackboard with French ultramarine. Paint the walls with the near-black mix, applying it quite dry on the 1 in (25 mm) brush to suggest texture. Use the same mix to define shadows.

NATURAL SHAPES

Whenever possible, let shapes form gradually from your washes of color rather than giving them an outline. It is better to work with shapes that develop naturally than to keep correcting hard edges once they have dried.

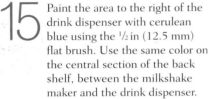

18 Paint the front edge of the counter with manganese blue using the ½ in (12.5 mm) brush. Use this color for other dark areas of the counter, which will make the surface look shiny. With the No. 9 brush, paint the cutlery with a steel-colored mix obtained by adding some French ultramarine to the near-black mix. Use the same color on the left of the counter and on the tops of the silver pots.

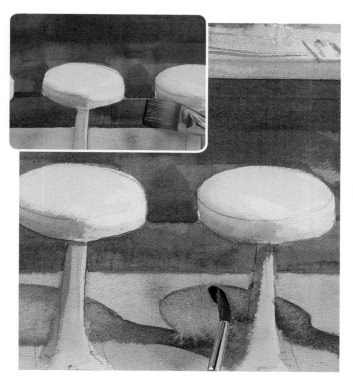

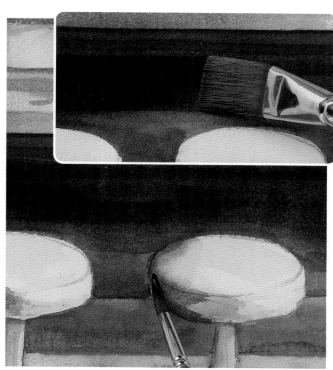

19 Paint the counter's skirting board with cobalt blue, which is a cool color. Use it also on the No. 9 brush for the shadows of the stools, diluting it as you move further away from the source of the shadows.

20 Use the near-black mix for the area under the counter. Run some water through the middle, then add more of the mix with the ½ in (12.5 mm) brush. Paint the edge of the seat on the left with this mix too. Blend it in.

21 Use the No. 12 brush to paint the leather seats with pure cadmium red. Leave some white areas on the right of each stool for highlights. Apply a second coat of red.

22 Make a rich red by mixing burnt umber and alizarin crimson. Use it on the No. 5 brush around the edges of the seats and for the shadows on the left. While the red is drying, lift some out from the left-hand side of the stools with a damp brush for a soft shine.

23 Paint the supports of the stools with a strong yellow ocher using the No. 5 brush. Use pure burnt umber for any dark details – for example, the bolts at the base of each support. You will need a fine brush for this detailing.

24 Warm up the shadows of the stools with burnt sienna using the squirrel brush. Add a little burnt sienna to the left, shadowed side of the stool stands, layering the colors. Let it dry.

26 Create reflections on the counter – for example, around the salt cellars – by lifting out some color with a clean, stiff brush. Use a small brush to lift out highlights from the glasses in front of the milkshake maker.

25 Paint the area around the top of the stools with the near-black mix of burnt umber and Prussian blue using the 1 in (25 mm) flat brush. Add more burnt umber for the dark shadows at the foot of stools using the No. 5 brush.

Diner ▶

The dominant green hue in this painting complements the red seats of the stools, heightening their impact. The odd number of seats – along with the fact that they are off-center – helps redress the symmetrical division created by the counter.

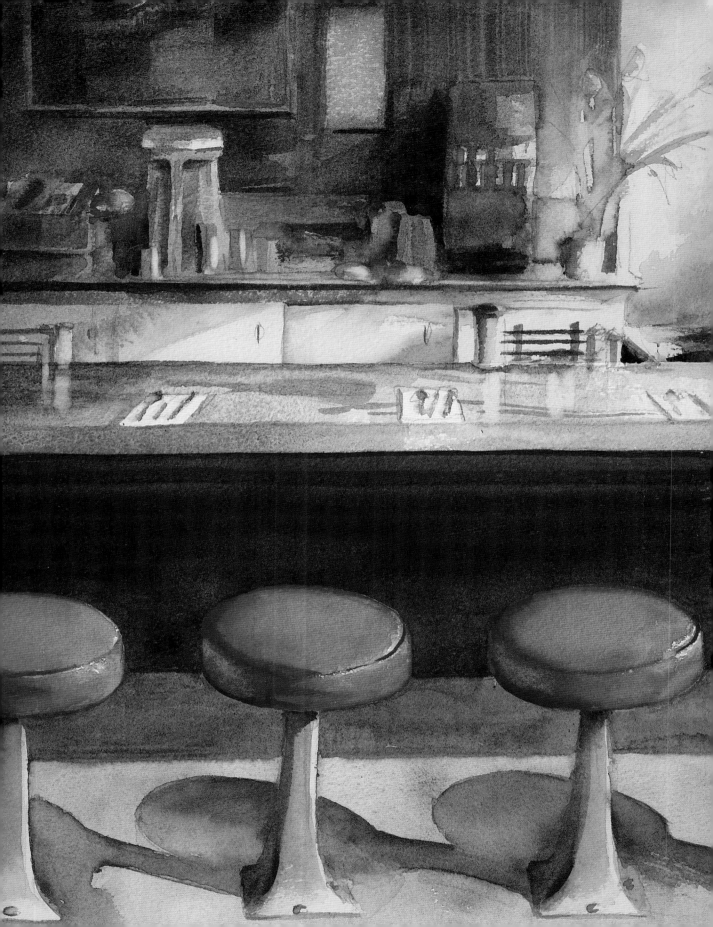

Glossary

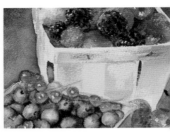

Alternation
Placing light tones directly next to dark tones, or alternating them, in a picture.

Artists' colors
The highest-quality watercolor paints, these contain more fine pigment than students' colors, so produce the most permanent results. They are also more transparent, which means they create more luminous paintings.

Balance
The relationship between elements in a painting. Correct balance gives a sense of stability to a composition.

Broken wash
A wash produced by letting a loaded brush glance over the top of the paper as it is drawn across it, so that areas of white paper show through.

Cold-pressed paper
Paper with a slightly textured surface that has been pressed by cold rather than hot rollers during its manufacture. It is sometimes called NOT paper.

Color mix
Paint that has completely dissolved in water to make a pool of color.

Color wheel
A visual device for showing the relationship between primary, secondary, and intermediate colors.

Complementary colors
Colors that are located directly opposite each other on the color wheel. The complementary of a secondary color is the primary color that it does not contain. Green is mixed from blue and yellow, so its complementary is red.

Direction
The visual pathway through a painting, direction controls the way you look at a picture. Horizontal direction creates calmness; vertical direction creates stability; and diagonal direction creates excitement.

Dominance
The greater importance given to one part of a scene rather than any other.

Dry brushwork
Loading a brush with very little paint and dragging it over the dry paper's surface to produce broken marks. This method is useful for creating texture.

Element
Any component or feature of a painting. It may be the focus of the picture or any supplementary part.

Feathering
Painting lines with water, then adding strokes of color over the top at an angle. The strokes of color are softened as the paint bleeds along the water lines.

Flat wash
A wash produced by painting overlapping bands of the same color so that a smooth layer of uniform color is produced.

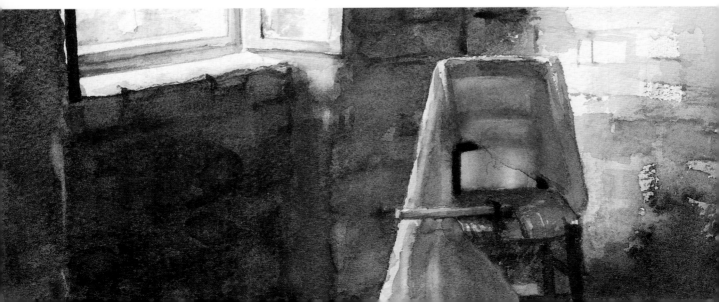

 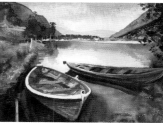 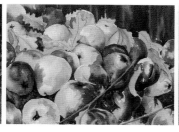

Glazing
Painting one transparent color over another that has been allowed to dry completely. The first color shows through the second to create a new color.

Gradation
Change used within a painting to create visual interest. Gradation in texture or the size of brushstrokes helps to build a focal point.

Graded wash
A wash laid down in bands that are progressively diluted or strengthened so that the wash is graded smoothly from dark to light or vice versa.

Granulation
The separation of paints when they are mixed together in a palette or on paper that occurs if the pigments they contain are of different weights. The resulting granulated mix is speckled and pitted.

Hake brush
A flat wooden brush with goats' hair bristles. Hake brushes are good for painting washes and covering large areas of paper quickly.

Hot-pressed paper
Paper with a very smooth surface that has been pressed between hot rollers.

Intermediate colors
The colors that appear between the primary and secondary colors on a color wheel. Intermediate colors are made by mixing primary colors and secondary colors together. Also called tertiary colors.

Landscape format
Paper that is rectangular in shape and is wider than it is high. It was traditionally used for painting large-scale landscapes.

Layering
Painting one color over another color that has been allowed to dry. Unlike with glazing, the colors used can be dark and opaque, so that the underlayer of paint does not show through the layer of paint that covers it.

Lifting out
Removing paint from the surface of the paper after it has dried. This technique is often used to create soft highlights and is usually done with a stiff, wet brush.

Linkage
Unifying different elements within a picture.

Luminous paintings
Paintings that take advantage of the natural transparency of watercolors, which lets the white paper shine through the paint.

Masking fluid
A latex fluid that is painted onto paper and resists any watercolor paint put over it. Once the paint is dry, the masking fluid can be rubbed away to reveal the paper or layer of paint it covered.

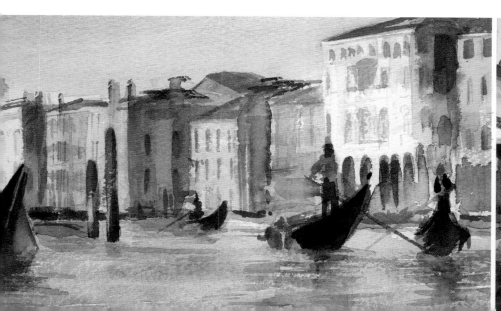

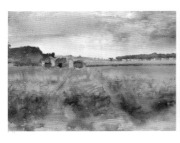
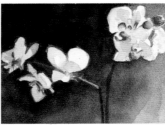

Negative shapes
These shapes are the visible spaces between objects. They are used to produce positive shapes in lighter tones by painting what is behind them.

Neutrals
Colors produced by mixing two complementary colors in equal proportions. By varying the proportions of the complementary colors, a range of semi-neutral grays and browns, which are more luminous than ready-made grays and browns, can be created.

Opaque paints
Dense, nontransparent paints that obscure the colors they are painted over. When opaque paints are mixed together, the results are dull.

Pan
A small block of solid, semi-moist paint, a pan comes in a plastic box that can be slotted into a paint box. Paints are also available in half-pans, so a wider selection of colors can be fitted into a paint box.

Portrait format
Paper in the shape of a rectangle that is taller than it is wide. It was traditionally used for standing portraits.

Positive shapes
This term refers to shapes of solid, three-dimensional objects that have their own color and tonal value.

Primary colors
The three colors that cannot be mixed together from other colors: red, yellow, and blue. Any two can be mixed together to make a secondary color.

Resist
A method of preserving highlights on white paper or a particular color by applying a material that repels paint. Materials that can be used as resists include masking fluid, masking tape, and wax.

Rhythm
Visual pathways that lead the eye through a painting.

Rough paper
Paper with a highly textured surface that has been left to dry naturally, without pressing.

Sable
Sable fur is used in the finest-quality paint brushes. The long, dark brown hairs have a great capacity for holding paint and create a fine point.

Scale
The size relationship between the various elements and their surroundings in a picture. It is often used to emphasize key elements in a painting.

Scraping back
Using a sharp blade to remove layers of dry paint in order to reveal the white paper below and create highlights.

Secondary colors
Colors made by mixing two primary colors together. The secondary colors are green (mixed from blue and yellow), orange (mixed from red and yellow), and purple (mixed from blue and red).

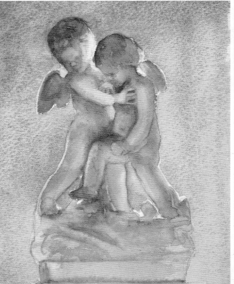

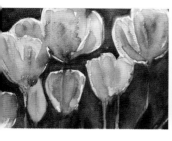
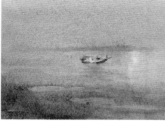
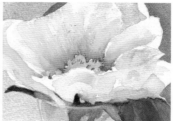

Sedimentary pigments

These pigments are opaque and nonstaining. They are heavier paints that tend to granulate by settling into the pits in the paper's surface.

Separator

A dark shape that is painted between areas of similar tone to help break them up.

Sizing

Sealing a paper's fibers with glue to prevent paint from soaking into the paper. Blotting paper is unsized and is therefore very absorbent.

Softening

Blending the edges of a paint stroke with a brush loaded with clean water to prevent paint from drying with a hard edge.

Splattering

Flicking paint from a loaded paintbrush onto a picture to produce blots and patterns useful for texture.

Squirrel brush

A very soft brush made from squirrel hair. Squirrel brushes do not hold much paint but are good for softening and blending colors.

Strengthening

Building up layers of paint to make colors stronger. This is frequently done because paint colors become paler when they are dry.

Stretching

A method of wetting paper with a damp sponge, taping it to a board, and letting it dry flat. Stretching paper helps to prevent the paper buckling when you paint on it.

Students' colors

A cheaper range of paints than artists' colors. Student's colors do not contain the same high level of pigments as artists' colors and therefore do not produce such good results.

Tone

The relative lightness or darkness of a color. The tone of a color can be altered by diluting it with water or mixing it with a darker pigment.

Toned paper

Paper that has a colored surface. White paint has to be added to colored paints to make the lightest tones on such paper.

Wax resist

A method of using candle wax to prevent the surface of the paper from accepting paint. Once applied, the wax cannot be removed.

Wet in wet

Adding layers of color onto wet paper or paint that is still wet. This method makes it possible to build up paintings quickly with soft colors, but it is less predictable than painting over paint that has already dried.

Wet on dry

Adding layers of paint on top of color that has already dried. Painting in this way produces vivid colors with strong edges, so the method can be used to build up a painting with a high degree of accuracy.

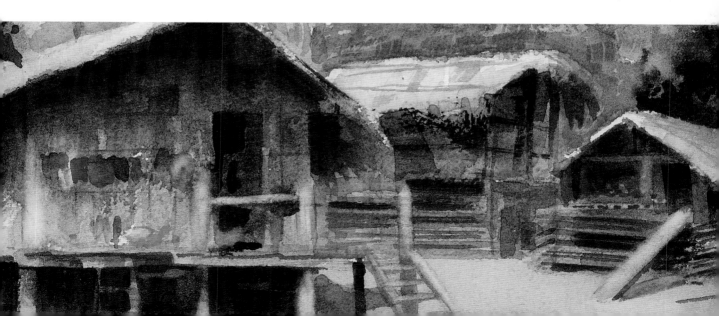

Index

Acknowledgments

PUBLISHER'S ACKNOWLEDGMENTS

Dorling Kindersley would like to thank: Simon Daley for jacket series style and Ian Garlick for jacket photography.

PACKAGER'S ACKNOWLEDGMENTS

Sands Publishing Solutions would like to thank: Andy Crawford for the photography; Neil Lockley for his invaluable editorial work at the photo shoots and beyond; John Noble for the index; Phyllis McDowell, Carole Robson, Anne Telfer, and Sara Ward for kind permission to reproduce their paintings; and Glynis Barnes-Mellish for being such a joy to work with.

PICTURE CREDITS

Key: t=top, b=bottom, l=left, r=right, c=center

p.26: © Private Collection/The Bridgeman Art Library (t); Phyllis McDowell (br); *p.27:* Carole Robson (t); © Whitworth Art Gallery, The University of Manchester, UK/The Bridgeman Art Library (cr); *p.50:* Carole Robson (t); © Private Collection/ The Bridgeman Art Library (bl); Sara Ward (cr); *p.51:* Carole Robson (cr); *p.76:* Anne Telfer (tl); © Private Collection/ Christie's Images/The Bridgeman Art Library (bl); *p.77:* Anne Telfer (cr); © Isabella Stewart Gardner Museum, Boston, MA, USA/The Bridgeman Art Library (tl); *p.102:* Sara Ward (br); © Haags Gemeentemuseum, The Hague, Netherlands/The Bridgeman Art Library; *p.103:* Sara Ward (cl); © Victoria & Albert Museum, London, UK/The Bridgeman Art Library (br).

All jacket images © Dorling Kindersley.